COMPLETE
BOOK OF
Drawing
Projects
Step-by-Step

COMPLETE BOOK OF
Drawing
Projects
Step-by-Step

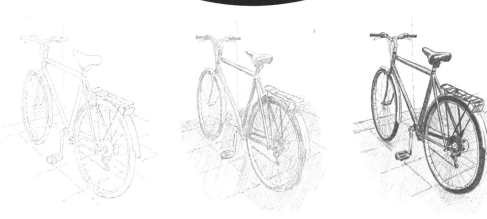

Barrington Barber

ARCTURUS

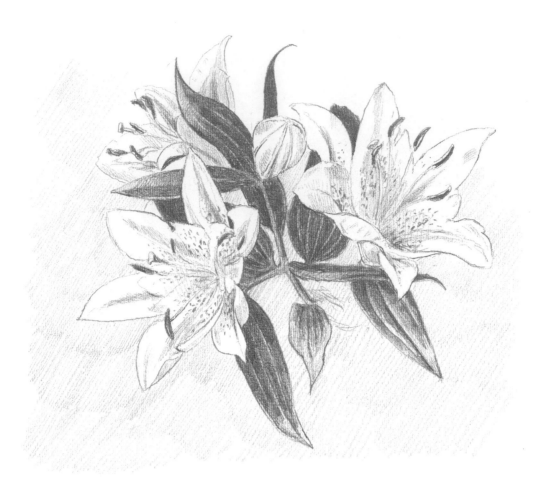

This edition published in 2016 by Arcturus Publishing Limited
26/27 Bickels Yard, 151–153 Bermondsey Street,
London SE1 3HA

ISBN: 978-1-78404-740-5
AD004467UK

Printed in China

INTRODUCTION

Drawing is a very rewarding pastime, and with careful looking and regular practice it is possible to create works that will please you and other people. In this book I have presented fifty subjects to draw, ranging from simple objects you can find in the home to outdoor scenes and landscapes. The projects are all broken down into five steps so that you can see how tone is applied at every stage of drawing. After each finished drawing is a blank page for you to make your own attempt, referring to my steps as you go. These projects are intended to build your confidence as a draughtsman, so that you feel comfortable handling the pencil and working across a range of subject matter. In time you will want to choose your own subjects, according to your interests and the objects you find around you – the world is full of things to draw. When it comes to drawing there is no substitute for practice, so pick up a pencil and get drawing!

Barrington Barber

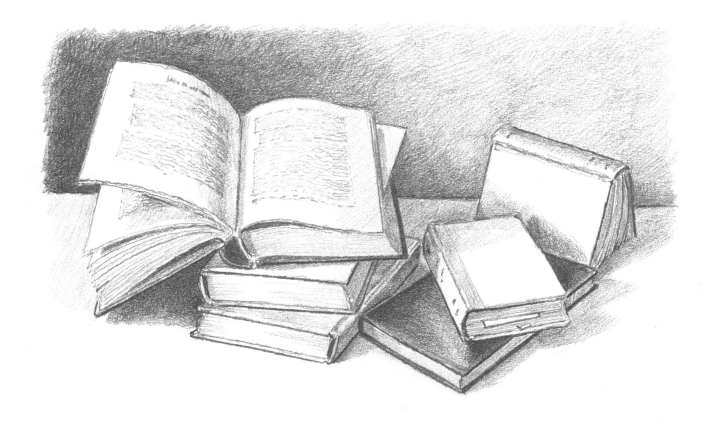

DRAWING EXERCISES

When you embark on your adventure as an artist, practising exercises in drawing techniques will really increase your abilities. The ones shown here will help to improve your observational skills and the way you use your drawing tool to describe what you see.

You don't need to spend a long time over these, but recurrent practice is very valuable for any artist. They are by no means the only exercises that are useful, but they are a straightforward way of getting you into the habit of drawing regularly.

Don't spend a lot of time trying to get them right – just practise as often as you can until you can do them quite swiftly without thinking too much about it.

1 First try these squares of tonal shading, starting with a scribbly technique and following with vertical strokes, diagonal strokes and then horizontal strokes.

2 Next try a set of squares of tone made by drawing multiple lines close together, first vertically, then overlaid horizontally. On top, draw diagonal lines both from the top left and the top right.

3 Next comes a series of squares that go from the very darkest tone you can make to the lightest, gradually reducing the pressure on the pencil until by the last square you can hardly see the tone at all.

4 Now draw a series of circles as near to the same size as you can manage, trying to make them perfectly circular – but don't be too slow and careful here, because the idea is to see how well you can control the pencil at speed.

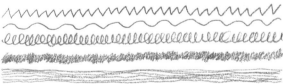 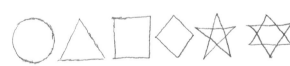

5 Follow the previous exercise with a set of horizontal marks to keep the feel of drawing fast without thinking too much about it – first zig-zag, then wavy, loops, smudges and finally horizontal lines very close together. Remember that the aim is to work fluently, without any hesitation.

6 Execute a series of simple geometric shapes that make you control the pencil more carefully: a circle, this time drawn deliberately and as slowly as you like; an equilateral triangle; a square; a square as a diamond; a five-pointed star, all in one line; and finally a six-pointed star in two overlapping triangles.

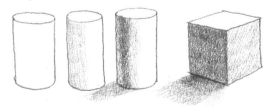

7 Now tackle three-dimensional geometry with a cylinder (left), carefully shaded to look as if it is solid, and a square with shading to achieve the same effect of three dimensions.

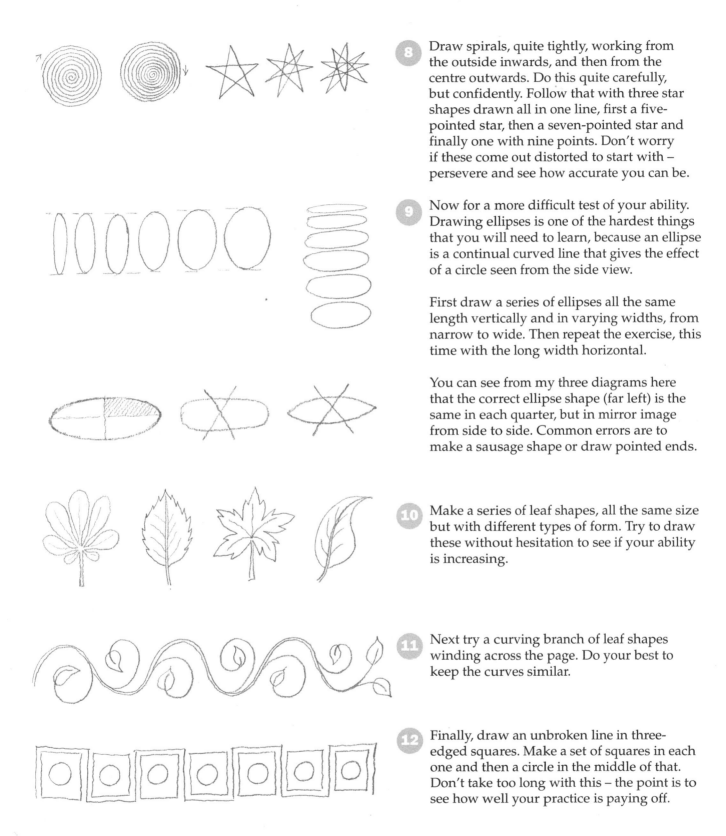

8 Draw spirals, quite tightly, working from the outside inwards, and then from the centre outwards. Do this quite carefully, but confidently. Follow that with three star shapes drawn all in one line, first a five-pointed star, then a seven-pointed star and finally one with nine points. Don't worry if these come out distorted to start with – persevere and see how accurate you can be.

9 Now for a more difficult test of your ability. Drawing ellipses is one of the hardest things that you will need to learn, because an ellipse is a continual curved line that gives the effect of a circle seen from the side view.

First draw a series of ellipses all the same length vertically and in varying widths, from narrow to wide. Then repeat the exercise, this time with the long width horizontal.

You can see from my three diagrams here that the correct ellipse shape (far left) is the same in each quarter, but in mirror image from side to side. Common errors are to make a sausage shape or draw pointed ends.

10 Make a series of leaf shapes, all the same size but with different types of form. Try to draw these without hesitation to see if your ability is increasing.

11 Next try a curving branch of leaf shapes winding across the page. Do your best to keep the curves similar.

12 Finally, draw an unbroken line in three-edged squares. Make a set of squares in each one and then a circle in the middle of that. Don't take too long with this – the point is to see how well your practice is paying off.

Having practised these exercises you should now be ready to try drawing some actual objects. So let's move on to the next step, and start the first project.

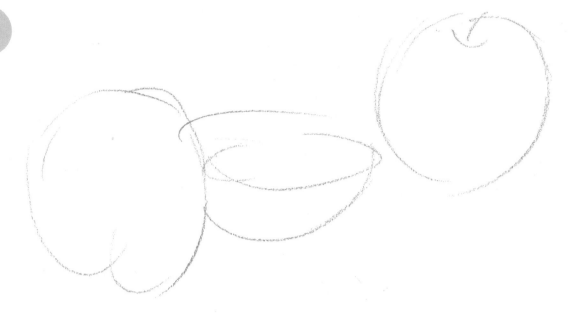

Here are a couple of apples, one cut in half to give more variety to the composition. Begin by sketching in the rough outlines of the pieces of fruit to get their shape and proportion right.

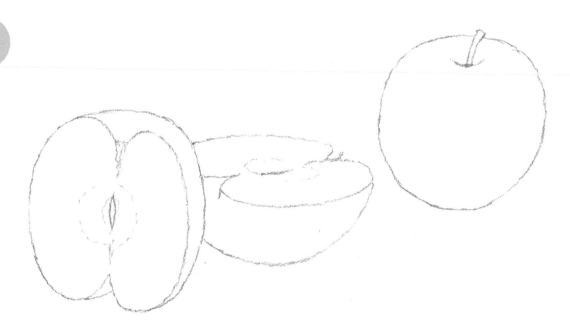

Then make a more careful outline drawing of the apples, ensuring the shapes are as accurate as possible.

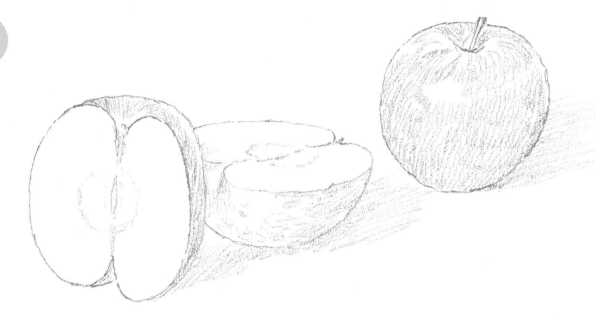

The next step is to put in the areas of shading across the whole picture, keeping it quite light. Note that I have drawn the skin of the apples with the pencil strokes going from the top to the bottom, as this texture resembles the colour variation on the apples.

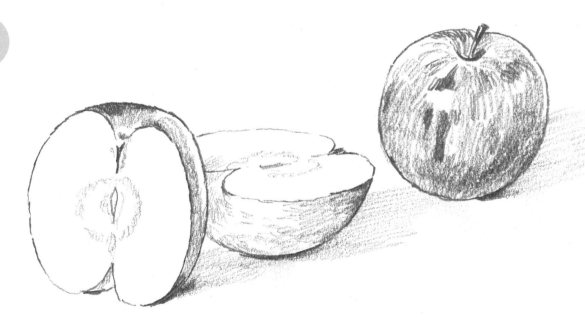

Then put in the darker tones that appear on the edges of the apple, because the roundness of the form increases the intensity of the tone at the very edges. Beef up the texture on the whole apple to indicate the colour.

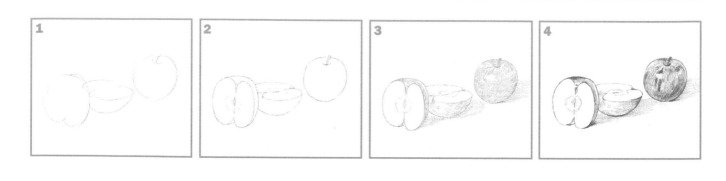

5

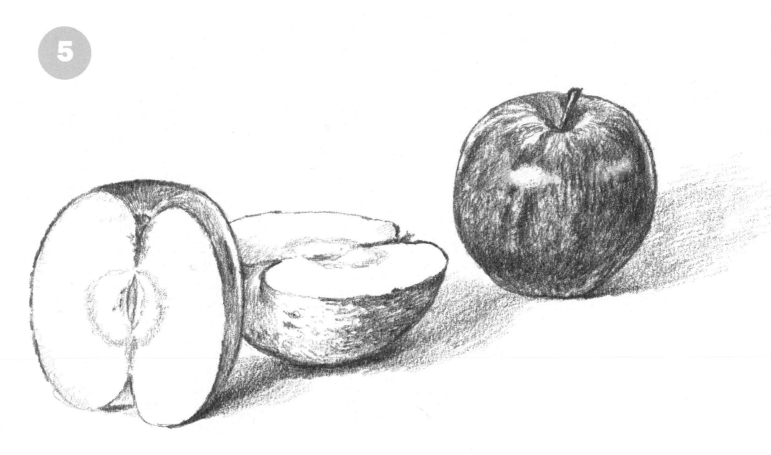

The last step is to work over the whole picture, refining the
marks until you feel that the drawing resembles the two apples
as closely as possible.

 Fruit is a great subject on which to practise your drawing skills, since it is readily available and comes in all sorts of shapes, sizes and textures. Peeling it or cutting it open as I have done here can add interest to your drawing.

A GLASS TUMBLER

1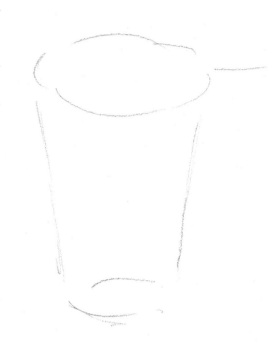

First draw a rough outline, getting the main proportion of the glass.

2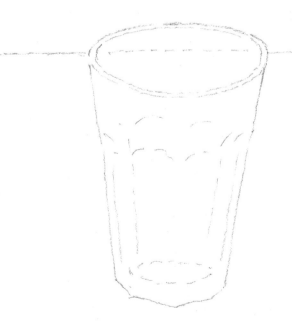

Next draw in the outline more carefully to get all the main indications of the shape. This is a project where your practice at drawing ellipses (see p. 7) will pay off.

3

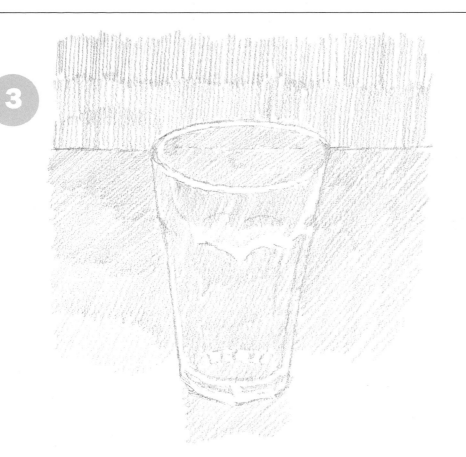

Next comes the main area of tone, put in lightly all over. Be careful at this stage to leave white spaces for the highlights, and remember to do the shadow around the glass as well.

4

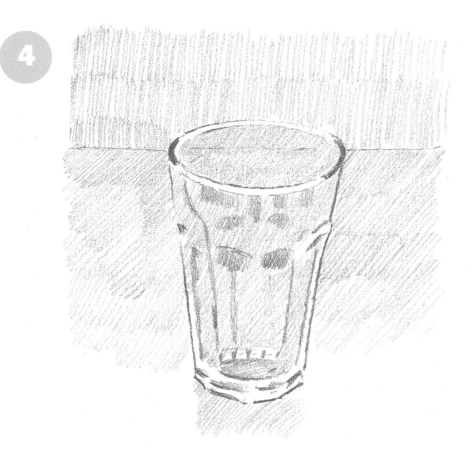

Then put in the very darkest tones, of which there are few on a subject such as this.

13

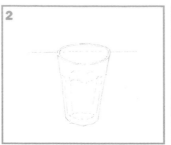
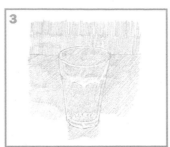
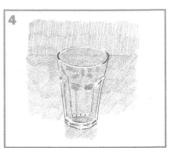

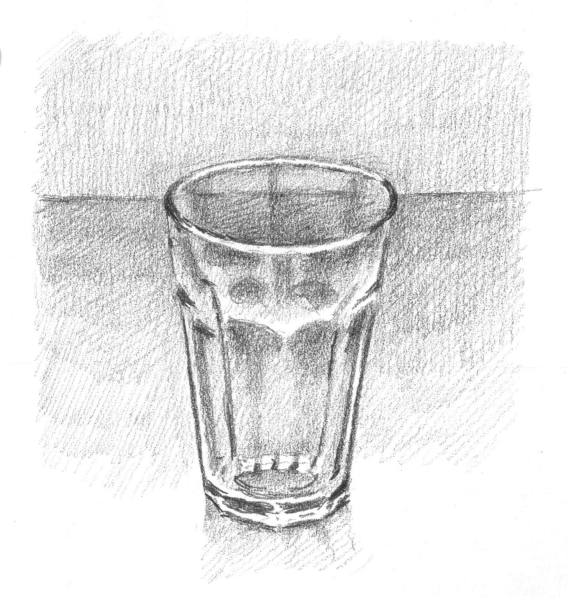

Continue to work over the whole glass and background until you are satisfied with the drawing. If you fill in any of the white highlights in error you can pick them out again with an eraser.

 Glass objects hold plenty of interest for an artist because of the light and dark reflections in them. Once you have mastered this drawing, try placing a glass tumbler against different backgrounds – but don't choose anything very complex at this early stage of developing your skills as you may become discouraged.

A DUSTPAN AND BRUSH

In the first instance, try to get a general idea of the shape and proportion of the objects with a simple, gently drawn set of lines. These give you the basic area of the drawing without establishing anything final – they can be erased if they don't fit in with the later drawing.

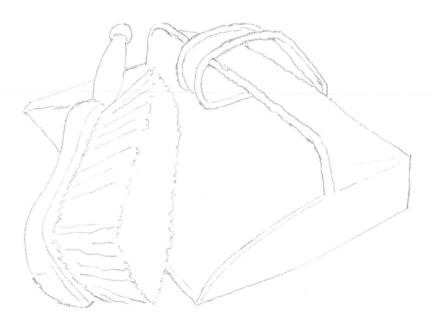

In the next stage you will need to be more accurate and careful, with an outline drawing describing the main structure and shape of the two objects. This is worth correcting extensively until you are convinced that you cannot make it any more accurate. Don't worry if you realize the final drawing has errors – this is all part of the learning process.

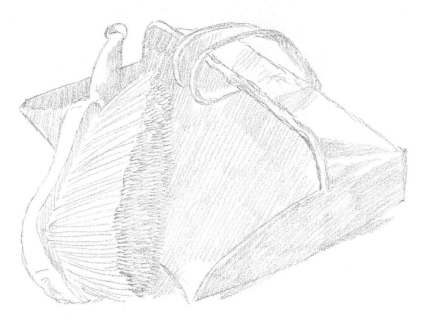

Now comes the moment when you need to show where the main area of shadow, or tone, lies. Draw this with a uniformly light tone over the whole area where there is any shade at all.

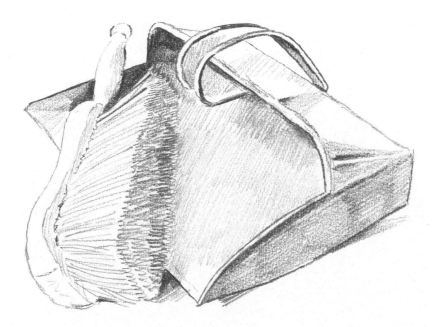

Next, put in the strongest, darkest tones. There's no need yet to concern yourself with the mid-tones.

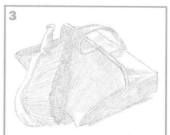
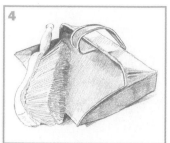

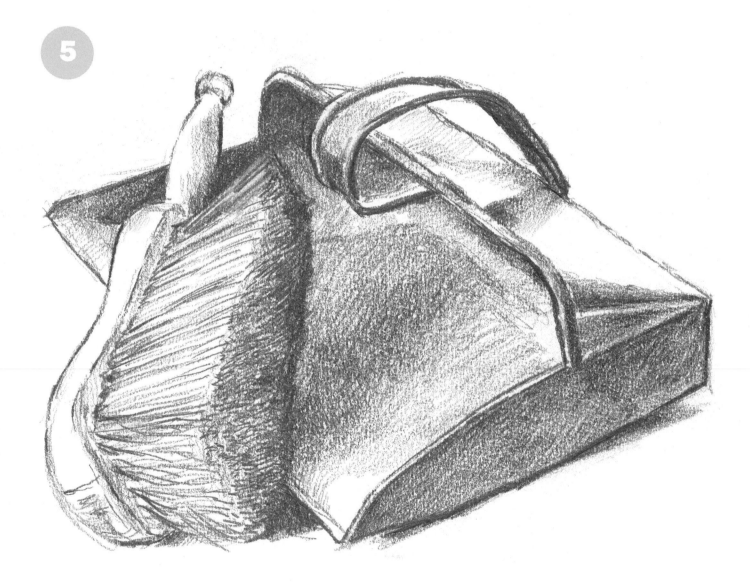

This is the culminating point, where you begin to harmonize all the areas of the drawing to try to give a convincing impression of the two objects as if they were lying in front of you. If they look reasonably three-dimensional you have done well.

Drawing something domestic and basic such as a dustpan and brush is a good way of starting out. Even the most ordinary objects in your immediate environment are interesting if you are able to depict them expressively. Your skill at doing that, of course, comes with observation and practice.

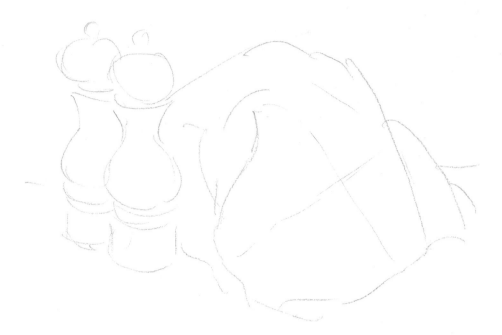

To start with, draw a very loose approximate outline of the main shapes of the salt and pepper pots and the cloth. This should be done very lightly and although not final it should give a fairly clear idea of the main shapes together.

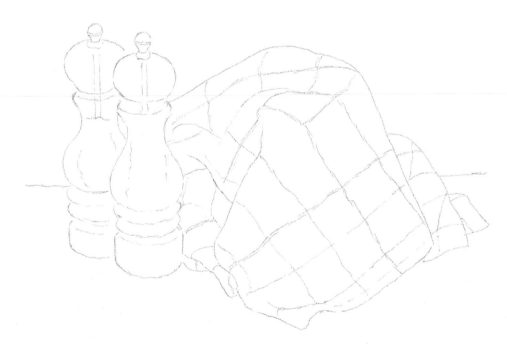

Now draw carefully, getting as accurate an outline as you can of all the objects. Take your time, erasing anything that is not right – keep the line thin and light to make this easy. Describing the squares on the tea towel is an interesting exercise in accuracy, but don't worry if you can't reproduce each one exactly.

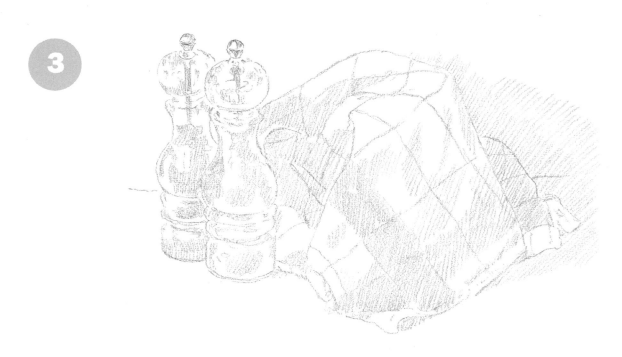

3

Next put in all the areas of tone that you can see, all in the same light tone, whether the shadow is dark or light. You will be able to build on this later. For the lightest areas, leave the paper white.

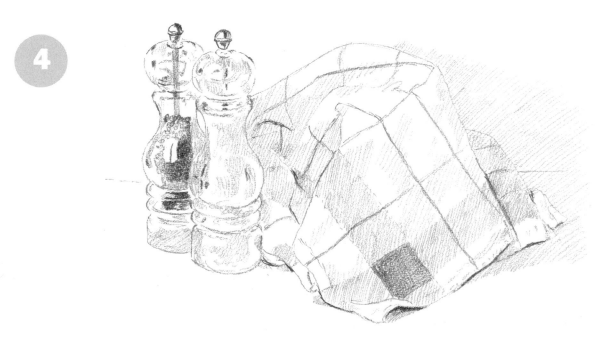

4

Now comes the moment to build up all the very darkest tones that you can see, putting them in strongly. Include any very defined parts of the outline in this process. Don't worry about the medium tones yet.

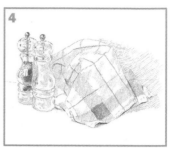

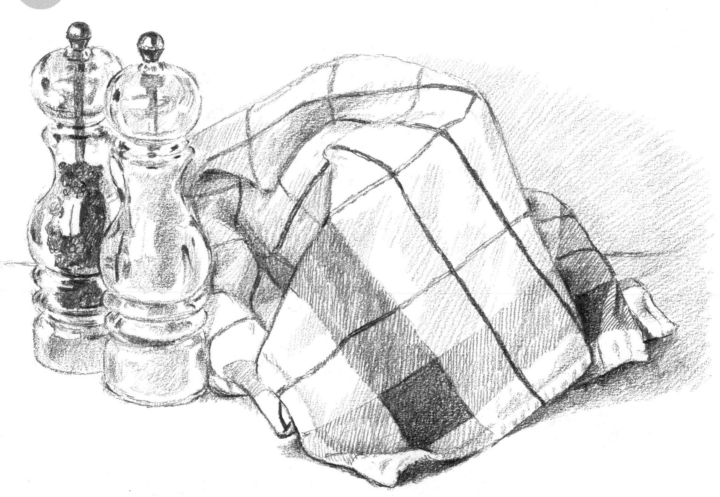

Finally, work over the whole picture, blending in the mid-tones so that the objects begin to look more like their reality. Go carefully here and keep working on it until you feel that it looks right to you.

 Look carefully before you start and assess the whole composition in order to make a good job of drawing it. Getting the shapes and tones of the pattern on the tea towel right will help to give greater conviction about its folds.

A BOWL OF FRUIT

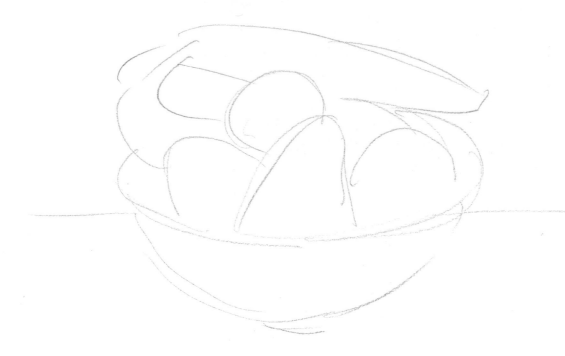

A simple bowl of fruit is an excellent subject for a still-life drawing, offering a variety of shapes and textures. First, make a quick, loosely drawn image to get the main proportion and shape of the objects.

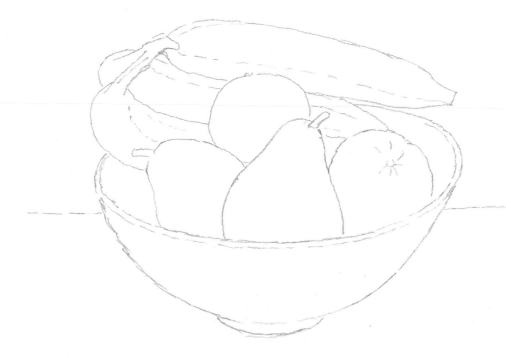

Move on to a more careful and accurate drawing, outlining all the pieces of fruit and the bowl. Keep the line light and thin so that you can easily erase it if necessary.

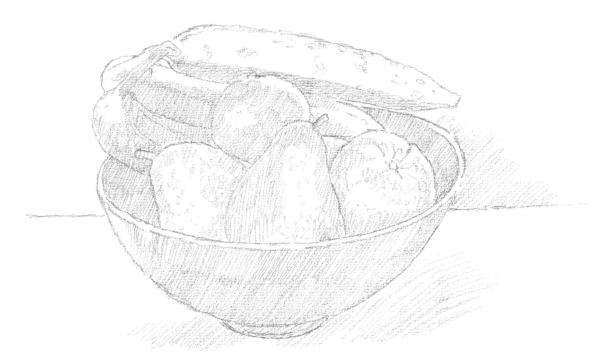

Now block in the main areas of shade, all in the lightest tone that you can achieve.

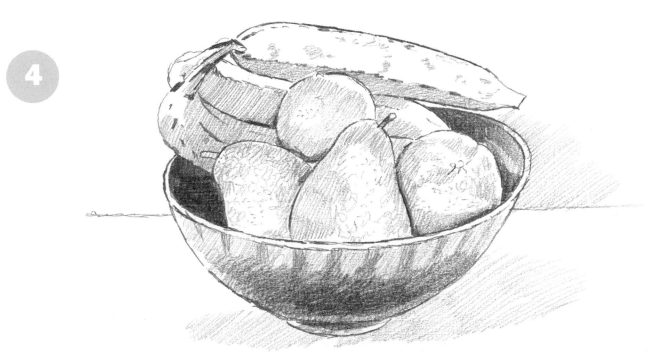

At this stage put in the darkest tones, which are mostly on the inside of the bowl and between the pieces of fruit. Also notice the markings on the fruit and put those in.

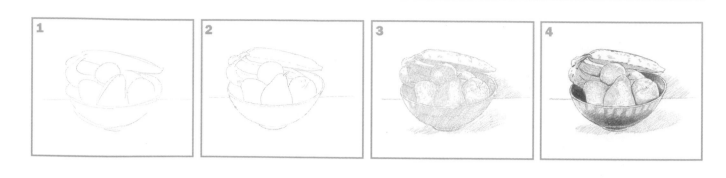

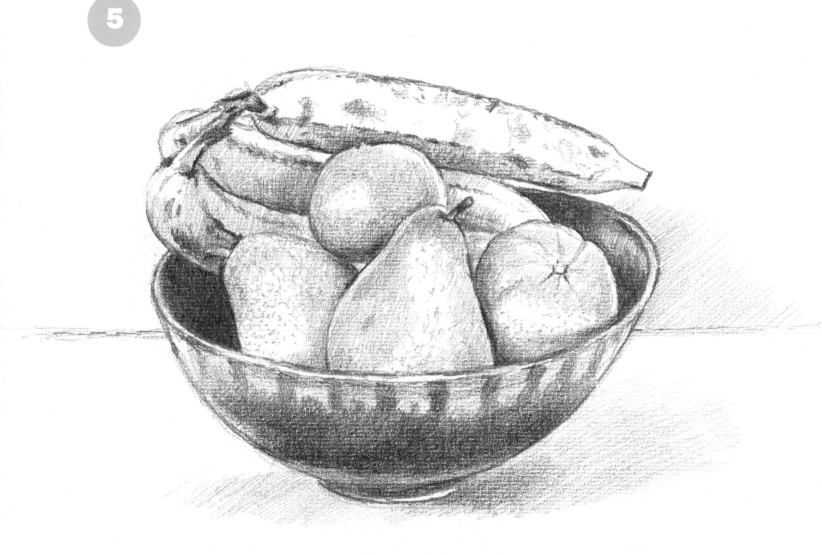

To finish, work over the whole picture, making the textures on the fruit more obvious and grading your tones to give a depth of focus.

 When you are drawing a bowl, adding the deeper shadows on the interior and the cast shadow around the base will give it weight and make your depiction more realistic.

1

As usual, begin with some loosely drawn lines that give you a good idea of how the elements of the composition relate to each other. Proportion is the most important thing here.

2

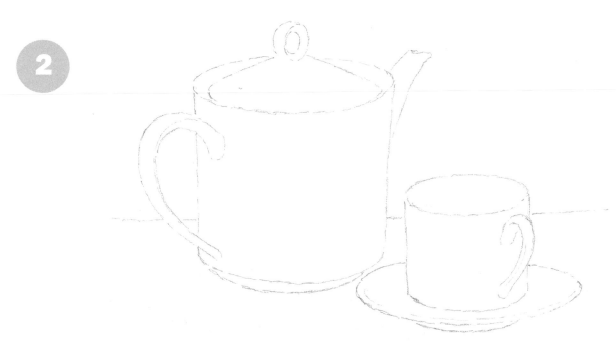

Now make a very careful drawing that shows the exact outline of each of the objects. The hardest outlines to get right are the ellipses of the saucer and the top and bottom of the teapot and cup. Work on these until they look right to you.

3

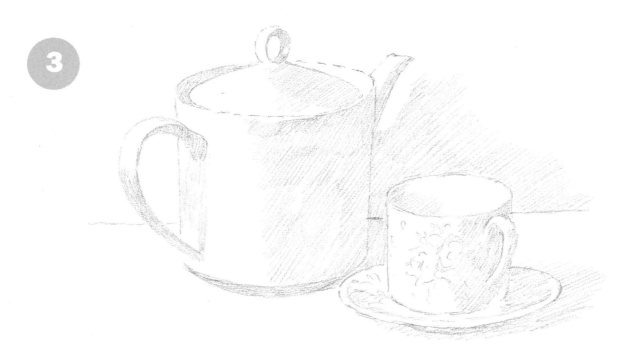

With your pencil, put in the lightest tone you can manage over all the areas of shade on the objects. Because the objects are mostly white it's particularly important in this drawing that the tone is very light.

4

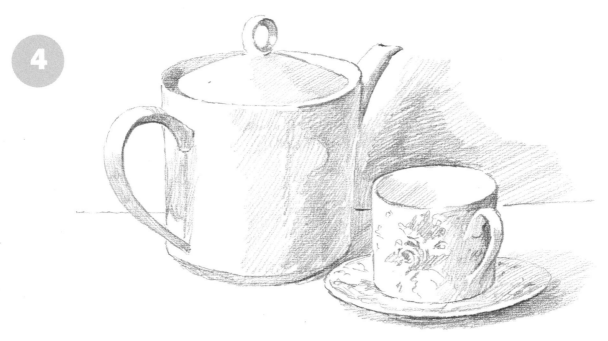

Now mark in the dark tones, which in this case are few and far between. Put in the beginnings of the floral pattern on the cup and saucer.

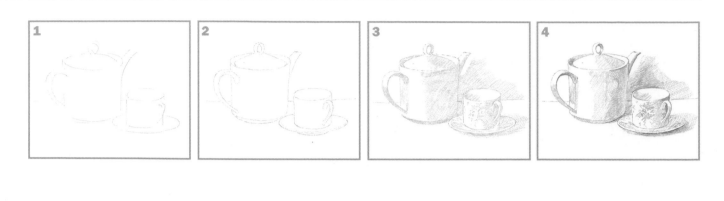

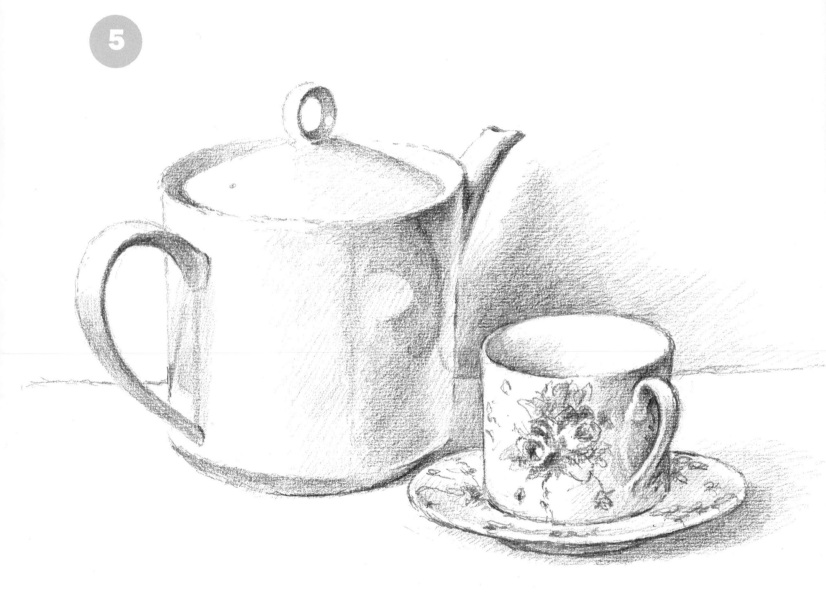

Finally, work over the whole picture, blending the tones and making the details of reflections and the floral pattern work more subtly.

 When you draw objects that are related to each other, one of the most important things is to get their relative proportions correct. You'll find your eye is quite good at measuring these things. Still, the ellipses here are tricky, and getting the exact shape of the handles can also be a challenge.

1

This is a piece of Saint Agur, a blue cheese, on a plate with a cheese knife. First make a sketch to show the main shapes of the plate, knife and piece of cheese. Keep this line lightly drawn and not too distinct.

2

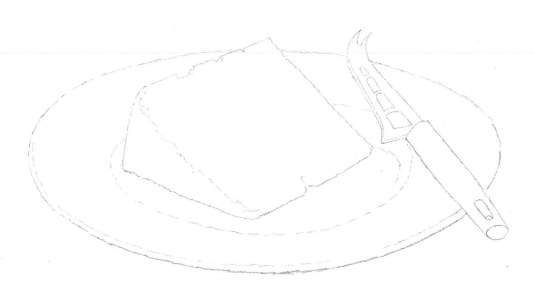

Now draw the outline as accurately as possible, taking care to get the shape and relative proportions of the cheese, plate and knife right. The hardest part is the ellipse of the plate's outer edge. It is worth working quite hard at this until you are really satisfied with it.

Now comes the time to put in the main areas of tone, all done with a very light layer of shading. As the light is coming from the left side of the picture, the top of the cheese will look darker than the side.

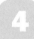

Put in the very darkest tones, such as the handle of the knife and the shadow around the edge of the plate. At this stage, also put in the blue veins on the surface of the cheese.

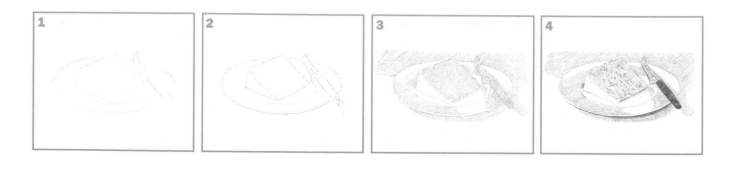

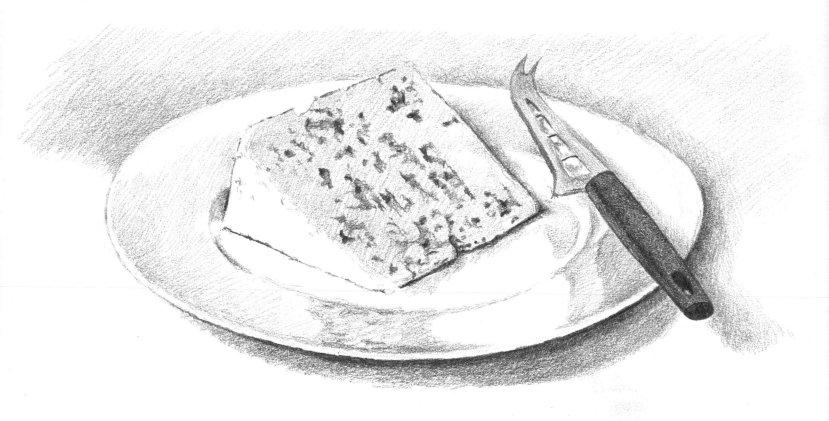

To finish the drawing, work over the whole area of the picture,
making the marks and tones more subtle and convincing to the eye.
This final stage is worth taking time over, because the results will be
better with a bit of effort.

 This project tests your ability to convey the smooth, slightly reflective surface of the plate with the dense texture of the cheese. Any cheese with interesting texture and markings would be good to draw.

These lilies were laid on a tabletop, giving a high viewpoint for the artist. Begin with a quick sketch of the main shapes.

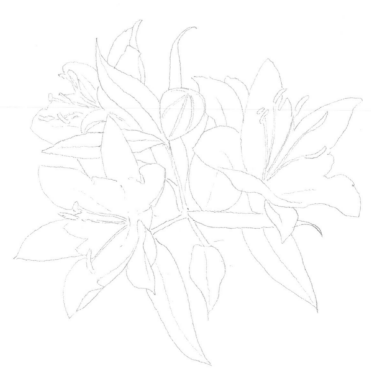

Next, explore the flowers and leaves in more detail, creating an accurately drawn outline and indicating the various parts that make up the flowers.

3

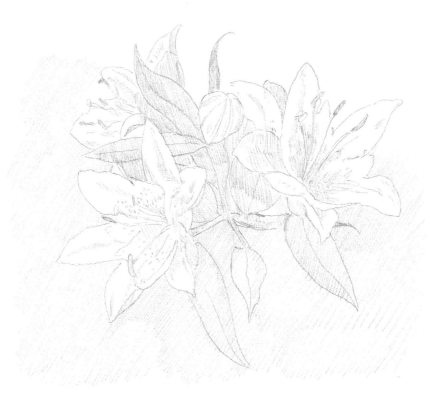

The next step is to put in a light tone over all the shaded areas, including the background.

4

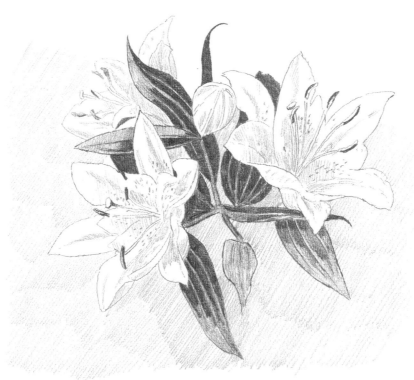

Next come the very darkest tones, which are mostly on the leaves and stamens. Take care to leave light lines along each leaf to give them their characteristic look.

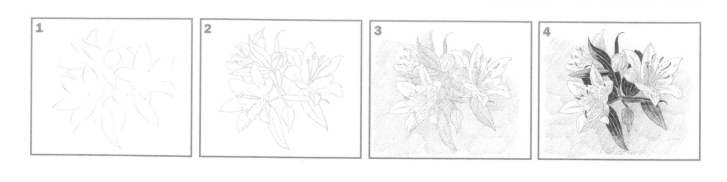

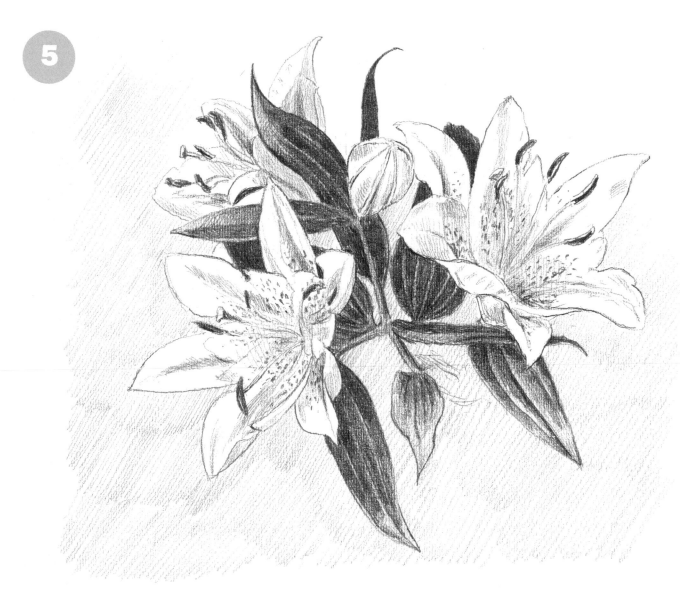

Lastly, build up areas of tone to give a more naturalistic look to the whole picture. Be careful not to overdo it, as flowers can start to look a bit stiff and unreal if you put in too much tone.

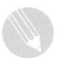 When you are drawing plants and flowers you will find that the leaves and petals have a tendency to move. Don't let this put you off: if you draw the basic shapes as accurately as you can the overall effect will be convincing and no one will know if they are slightly out of place from how they were in reality.

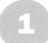

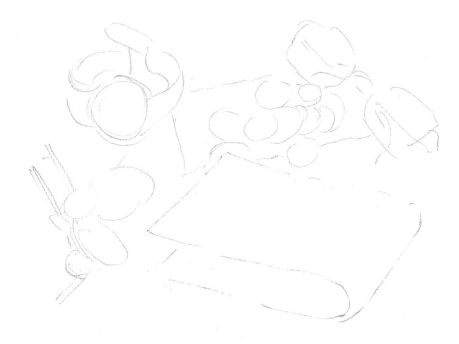

Here is a group of miscellaneous objects which might be found after someone had emptied their pocket or handbag. They are all quite small, so this is an exercise in miniature drawing. Make a quick sketch of the main shapes that you can see without aiming for precision.

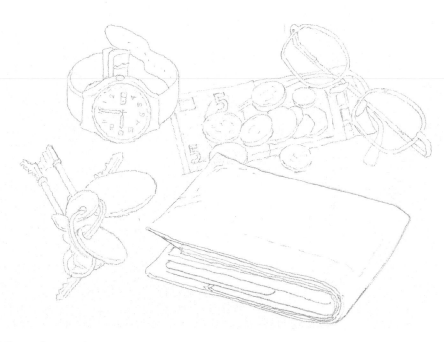

Next draw the shapes of all the objects with as precise an outline as you can manage, then put in the fine details such as the numbers on the face of the watch.

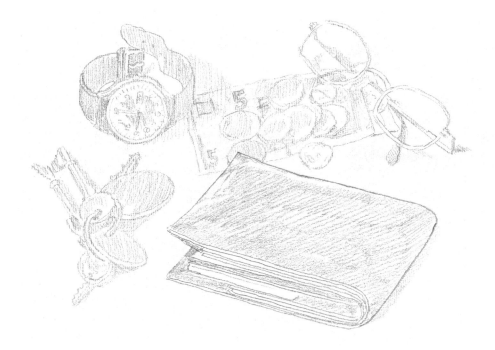

Put a light tone over all the areas where there is shade, including the cast shadows on the surface that the objects are lying on.

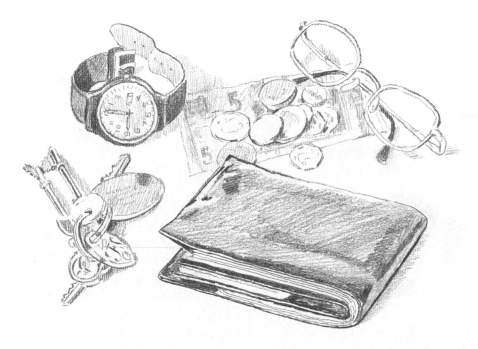

Now mark in the strongest tones, which are mainly found on the watch and wallet. Because the objects are all small, you will have to look hard to see exactly where these dark tones are.

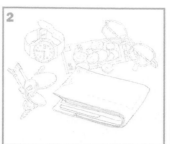
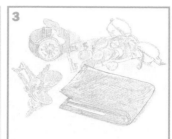
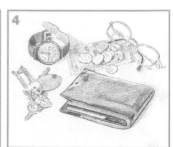

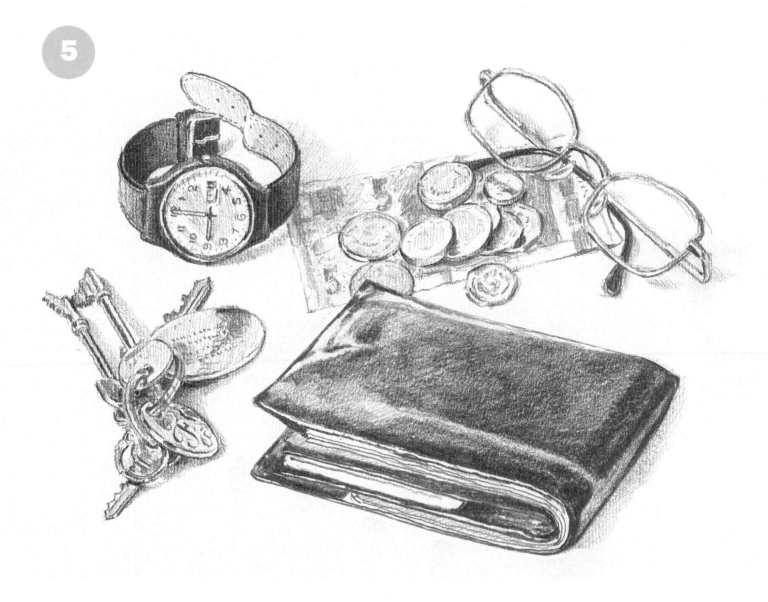

Now put in all the medium tones, showing the different textures of the objects as well as you can – they vary from the hard reflective surface of the keys to the matt paper of the banknote.

 A themed still life such as this is interesting for the viewer as it has
a narrative that is lacking from a collection of disparate objects.
You will be able to find plenty of themes to draw in your home.

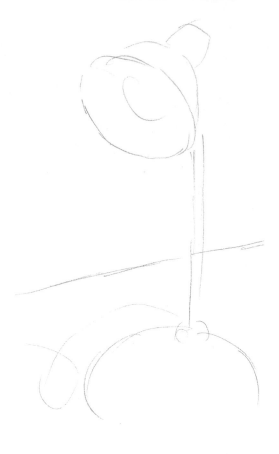

1 This small desk lamp is relatively easy to draw, but it does require a bit of precision. To start with, just sketch in the main areas of the shade, stem and base, also indicating the surface area that the lamp stands on.

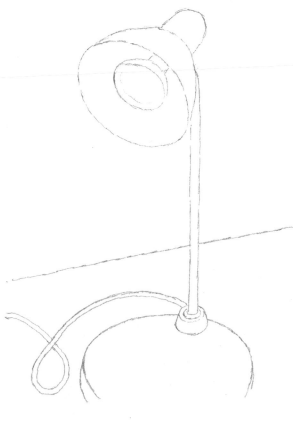

2 Next draw in the whole shape of the lamp with as much precision as you can muster. You will probably find that the hardest bit is getting the ellipses of the shade and base correct.

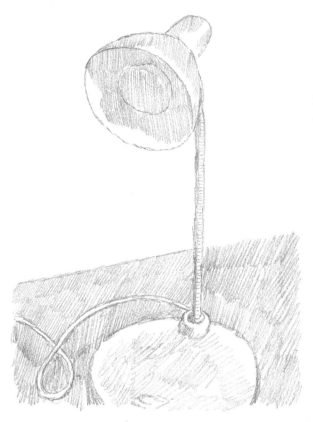

Now cover all the areas that are in shadow with a light, even tone of pencil marks. Note where the light catches the rim of the shade and base.

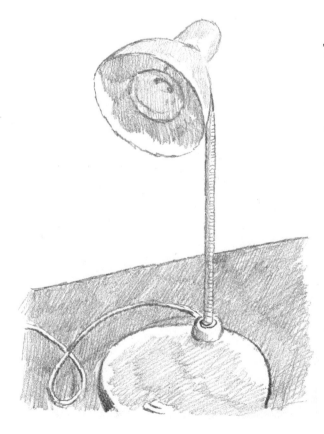

The next stage is slower but important, because now you need to show where the darkest areas of tone are to be seen. At this stage I used a thick 4B pencil, which gives a pleasing soft black mark.

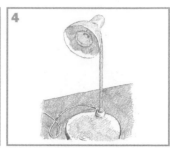

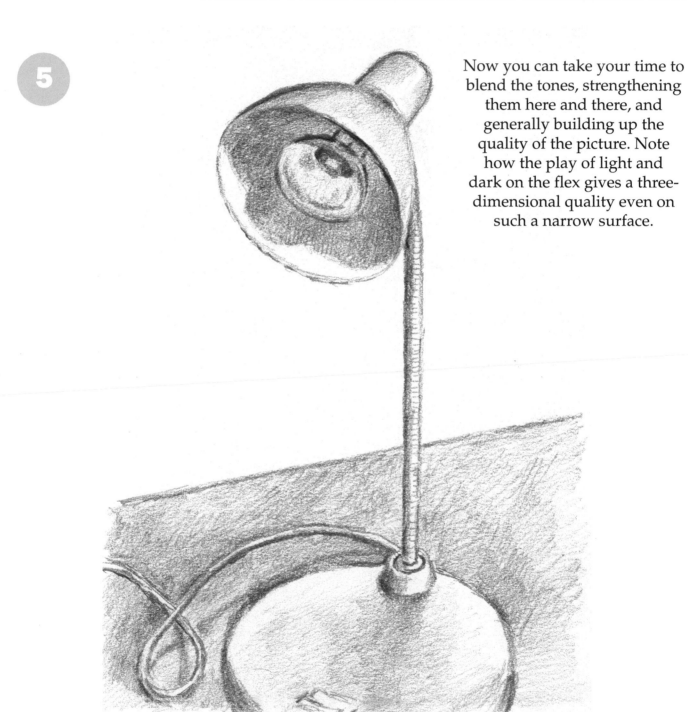

Now you can take your time to blend the tones, strengthening them here and there, and generally building up the quality of the picture. Note how the play of light and dark on the flex gives a three-dimensional quality even on such a narrow surface.

 For this project, try using a thick soft pencil that makes a dark mark easily. If you are drawing your own lamp, you can discover the differences in handling another shape.

1

This water filter such as is found in many modern kitchens is an interesting challenge – the clear plastic conveys a slightly different effect from that of an ordinary glass jug. First sketch in the main shape, establishing the outline.

2

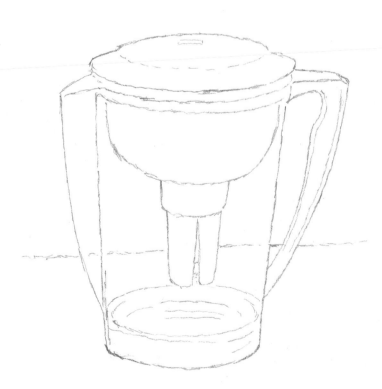

Now, more carefully, draw in the water filter in its entirety, getting the proportion and curves of the parts as accurate as possible. This is where an eraser comes in handy.

3

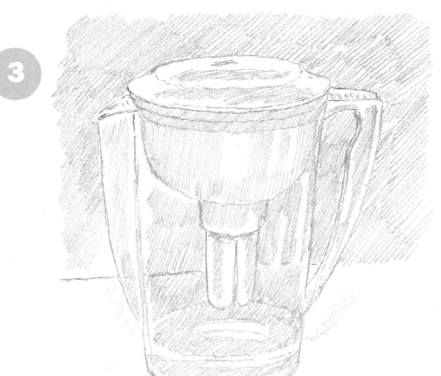

Now start to put in all the areas of tone, all in the same density, which at this stage should be quite light in tone. Notice how the background tone helps to show off the shape of the object clearly.

4

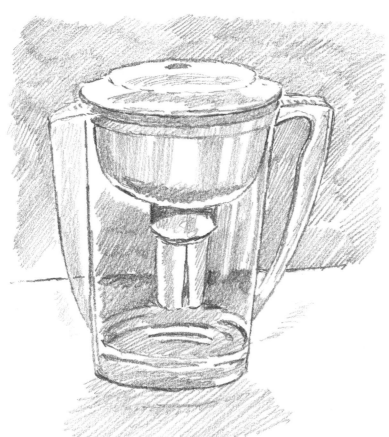

Now put in stronger tones, the darkest that you can see. The aim is to make the difference between the lightest and the darkest very evident.

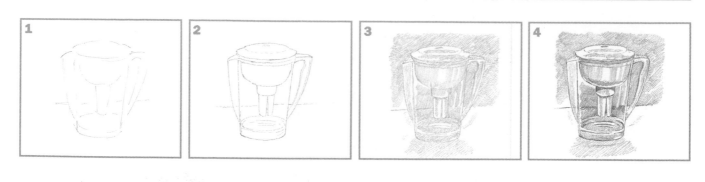

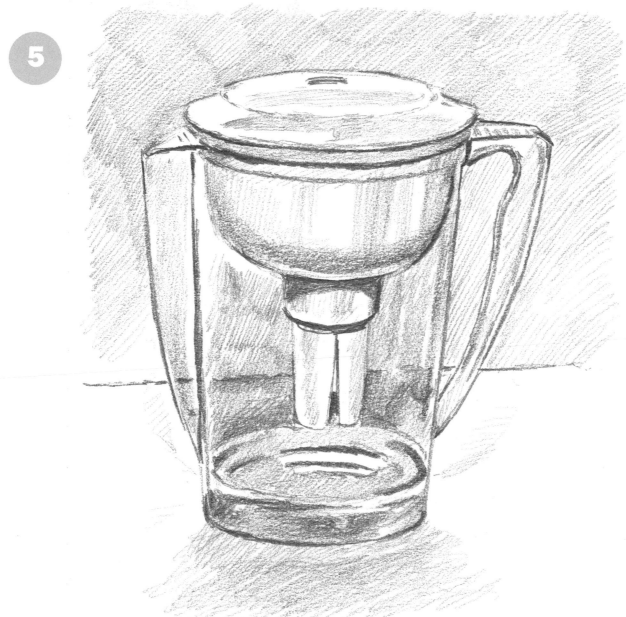

Finally, build up all the in-between tones and if necessary strengthen any darker ones. You will find that adding more tones can alter the apparent strength of earlier applications.

 With a plastic object such as this, the main considerations are how you can best show the shiny parts that reflect the light most strongly and where the darkest shadows lie.

A KITCHEN STILL LIFE

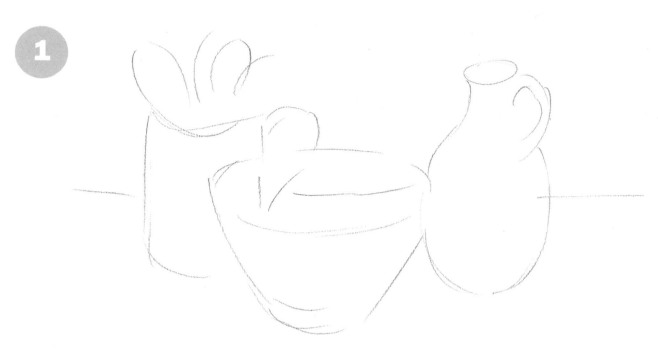

Here is a simple still life of three objects that you might find in any kitchen: a glass bowl, a small pot with a handle and a mug with teaspoons in it. First, lightly draw the rough area of all the shapes in relation to each other. Take care not to make the lines heavy, because you will want to erase most of them later.

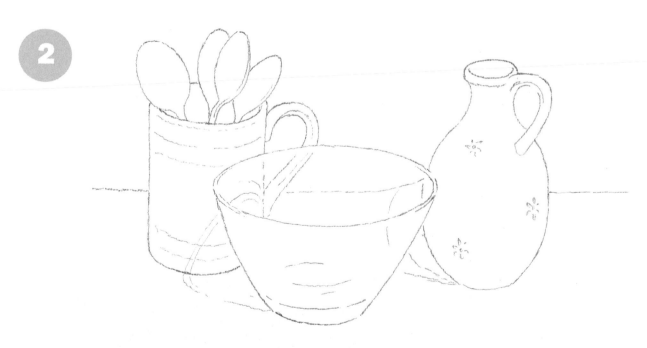

The next stage is to draw in an outline that shows everything in the composition as accurately as you can draw it. Make a light indication of the pattern on the mug and the pot.

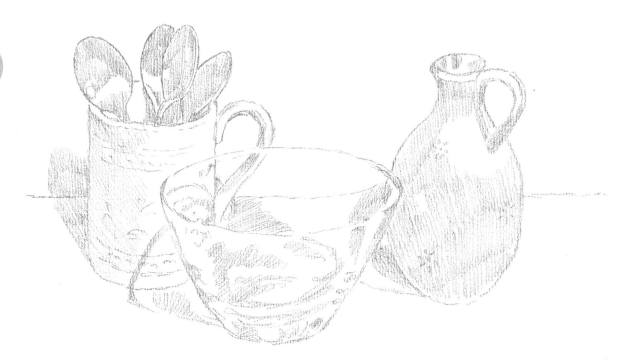

When the outline is complete, the next stage is to put in a lightly drawn version of all the areas of shade that you can see on the objects. This begins to give the composition some body.

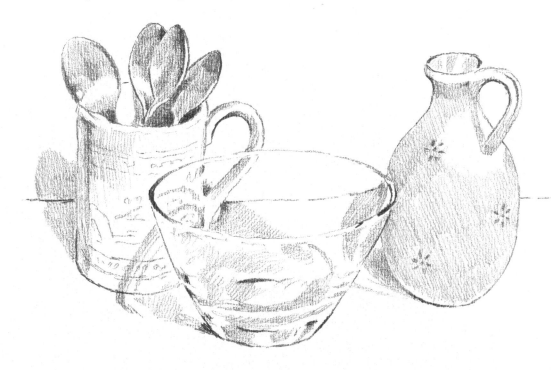

Now build up the very darkest shadows in the picture, putting them in as strongly as you can. The greatest area of dark tone is in the interior of the mug.

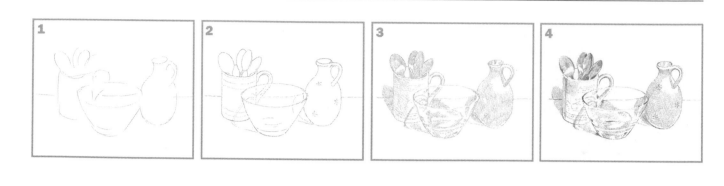

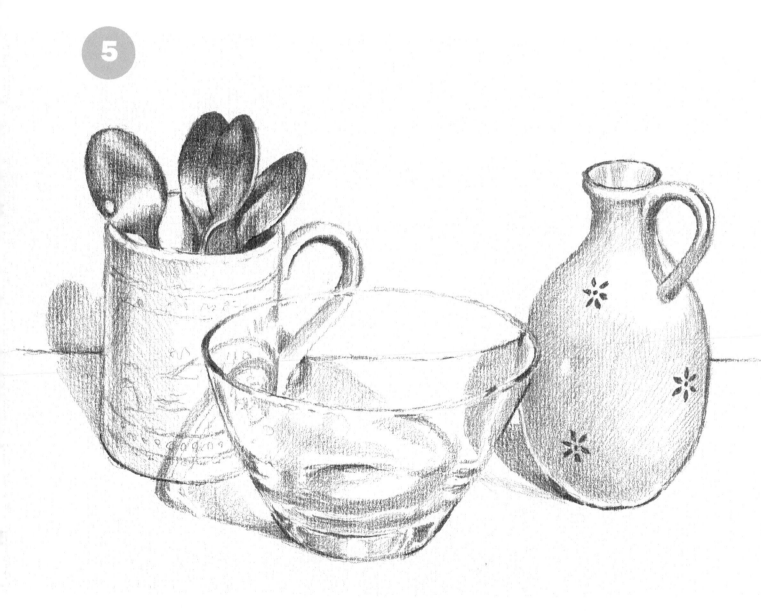

Lastly, build up all the mid-tones over the whole composition.
Working carefully and patiently, make your marks as subtle as you
can, describing the gently rounded forms.

 Having practised with this domestic still life, you can now arrange your own composition to draw. The kitchen is an excellent source of still life objects of all shapes, sizes, materials and textures.

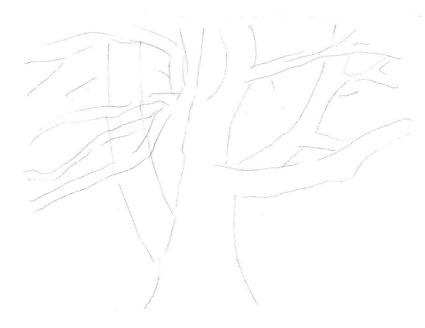

This drawing is not of the whole tree, but of the main base area of the trunk and large branches, so you will not have a lot of leaves to tackle. First, draw in the main shapes of the spreading branches and the trunk, so that you have a good representation of the main shape of the tree. This will not include the ends of the branches.

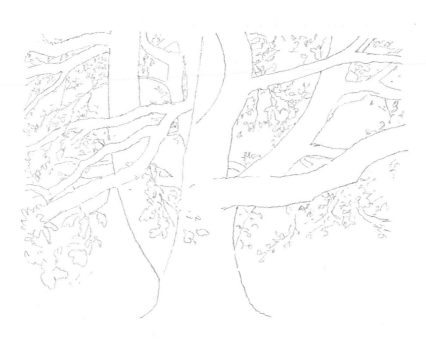

Now, as accurately as you can, draw in a simple outline of all the main shapes and this time include any leaves that come into your area of drawing. Don't try to draw every leaf – just the main masses of foliage that you can see.

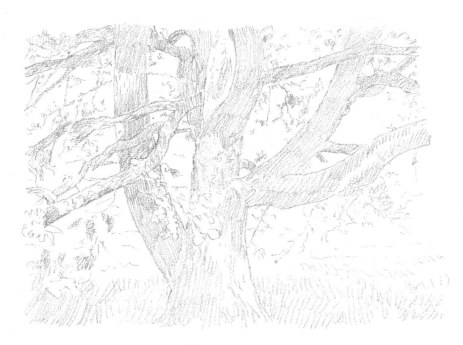

Next comes putting in the main tonal areas, and as you can see these are over most of the branches and trunk, which are shaded by the leaf canopy. Put them in with a uniform light tone and include the grassy ground under the shade of the tree.

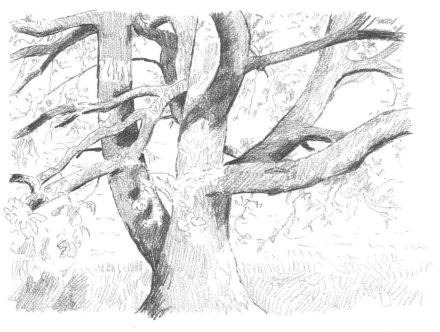

Now you can put in the darkest tones as well and you will see how this begins to give a three-dimensional feel to the whole picture. Shade only the very darkest areas at this stage.

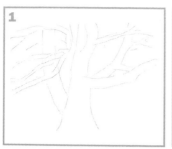 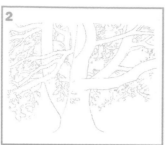 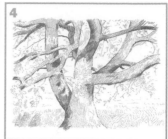

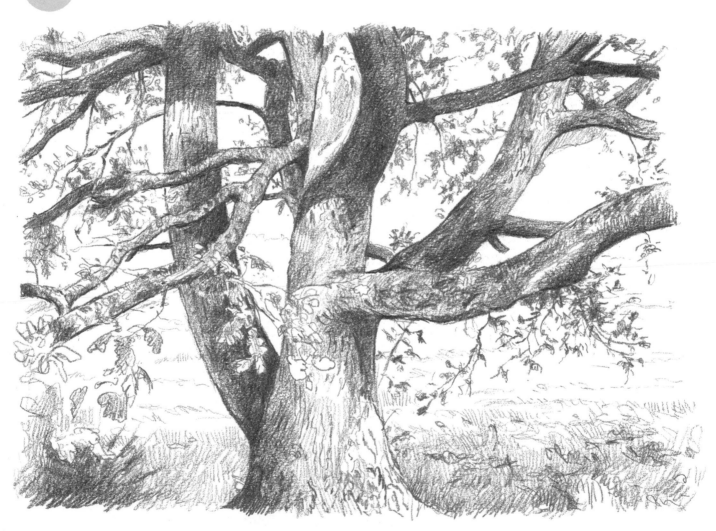

Now comes the slowest part of the drawing, where you have to blend all the necessary tones together until they begin to make more sense to the eye. Some of this will be the textural differences that you find on the trunk and branches and in the grassy area under the shadow of the tree. Continue until you feel that you have a reasonable likeness of the tree here.

 Once you have completed this drawing, go out and find an attractive tree that you can draw from life using the same method. To prevent your paper being ruffled by a breeze, take a stiff-backed pad of drawing paper or a small, thin drawing board with paper attached to it with masking tape, which won't damage the surface when you remove it.

A WINE BOTTLE AND GLASS

1

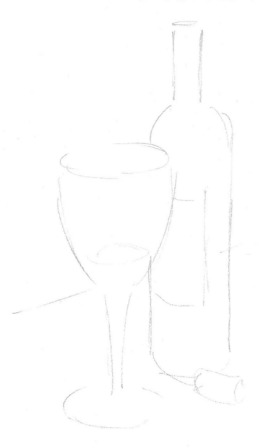

In this picture the bottle of wine has been uncorked and some wine poured into the glass. The cork lies alongside the bottle, emphasizing the narrative element. First, indicate with sparing marks the main shape and proportion of the objects in the composition. Note how they relate to each other in place and size.

2

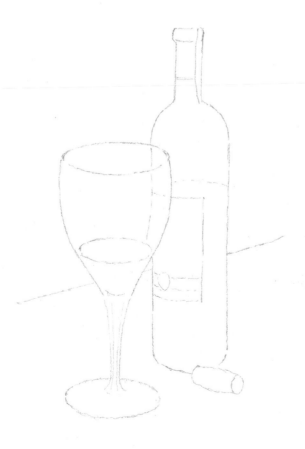

Now draw the outline more carefully to show exactly how the objects appear to you. Note how the part of the bottle seen through the side of the curved wine glass will have a slightly different shape from the actual bottle.

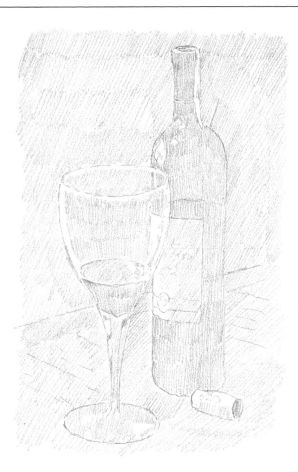

Make a start on the tonal work, giving all shaded areas the same light strength of tone at this stage. As you can see, most of the picture is covered in tone – be careful to reserve white paper for the minimal areas of highlight.

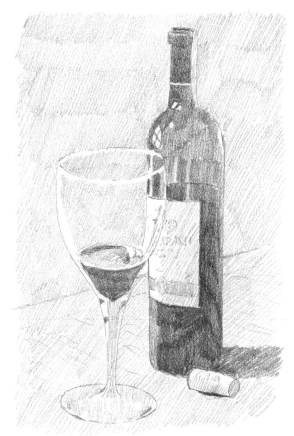

Now put in the darkest tones, which in this case are mostly on the bottle and the wine in the glass.

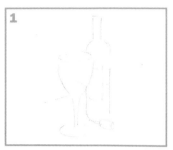

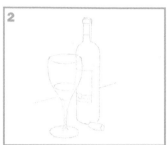

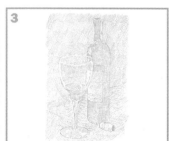

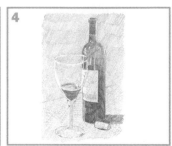

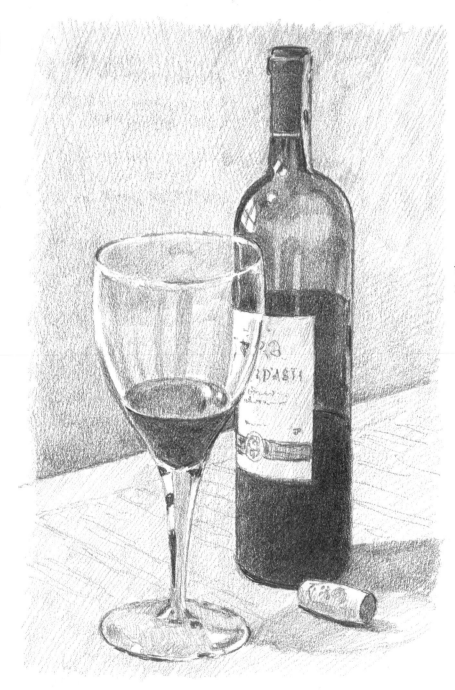

Finally, work over the whole picture, graduating the mid-tones smoothly to give more conviction to the rounded forms.

 Once you feel you have mastered this drawing, try other compositions that offer reflections on glass to study.

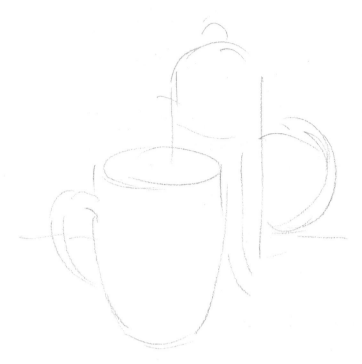

Start with the lightest possible sketch of the coffee pot and mug, adding just a line to indicate the edge of the surface they are on. A few quick marks give an impression of the main shapes.

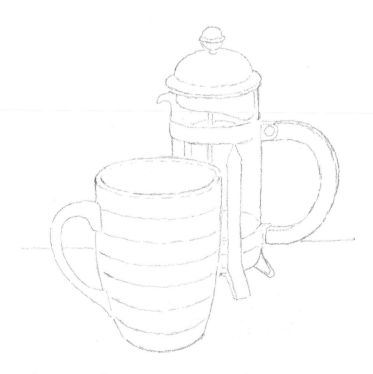

Now you have to take more care to get the objects as accurately drawn as is possible. Keep the line light and correct anything that doesn't quite fit at this stage.

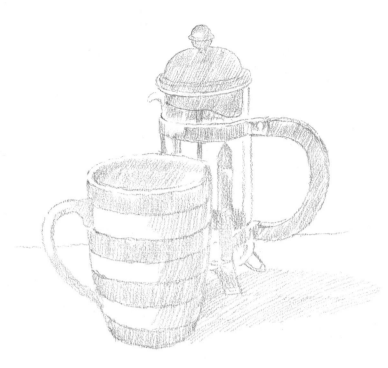

The next step is to put in all the areas of tone observed in the picture,
keeping the tone as light and even as possible.

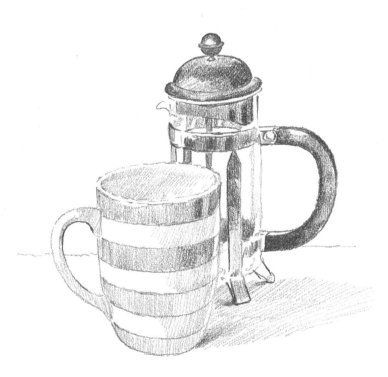

Next build up the tone with the darkest areas, not worrying at this
stage about the mid-tones. The lid and handle of the coffee pot are
obviously rather darker than most of the mug.

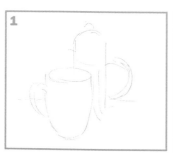
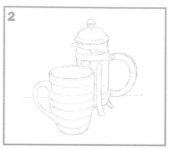
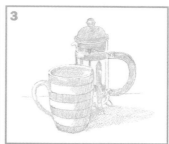
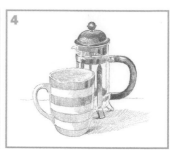

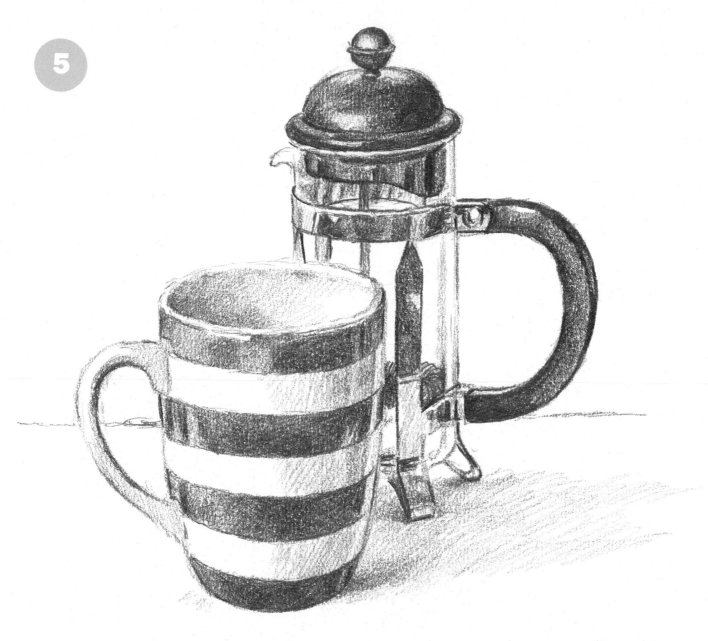

Finally, build the tone more carefully, getting all the varieties of mid-tone in to build a three-dimensional effect. Don't rush this stage, as it needs careful consideration.

 When you have finished this drawing, try other arrangements of everyday items. Your composition will be more interesting if you choose eye-catching and well-designed objects.

1

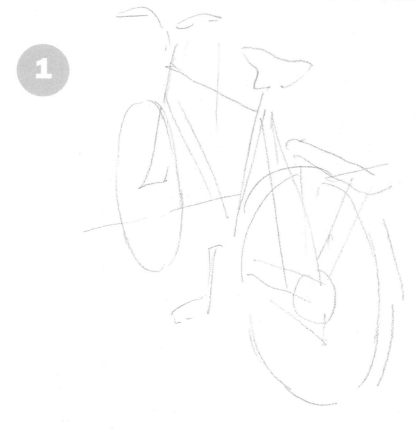

Draw in the main shape of the bicycle, which shouldn't be too hard. However, look carefully at the ellipses of the wheels, as these are not both the same.

2

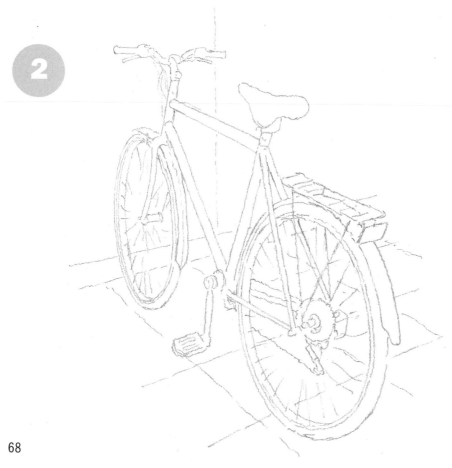

Now make a very careful outline of the bicycle to lay the groundwork for your finished drawing, taking care to get the proportions correct.

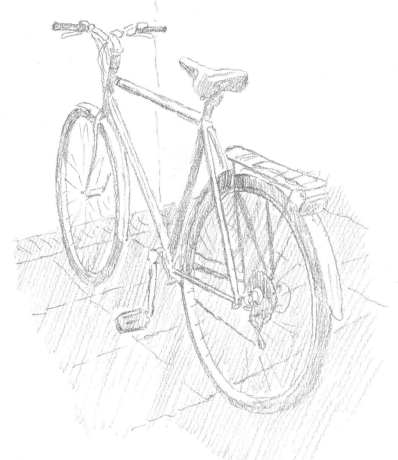

Now draw the areas of tone, which are mainly across the background pavement.

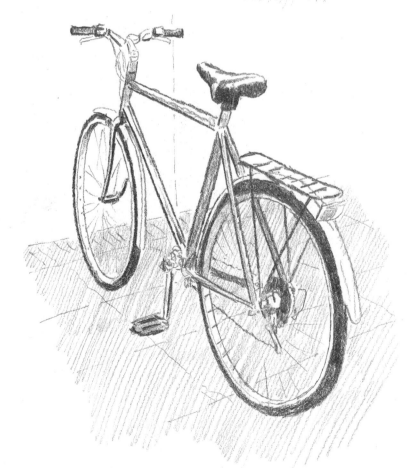

The darkest tones come next; these are principally found in the tyres and saddle.

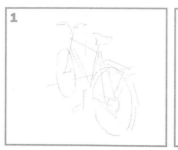
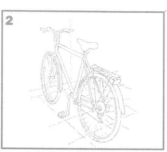
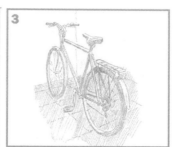
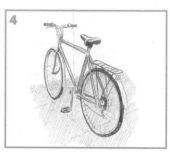

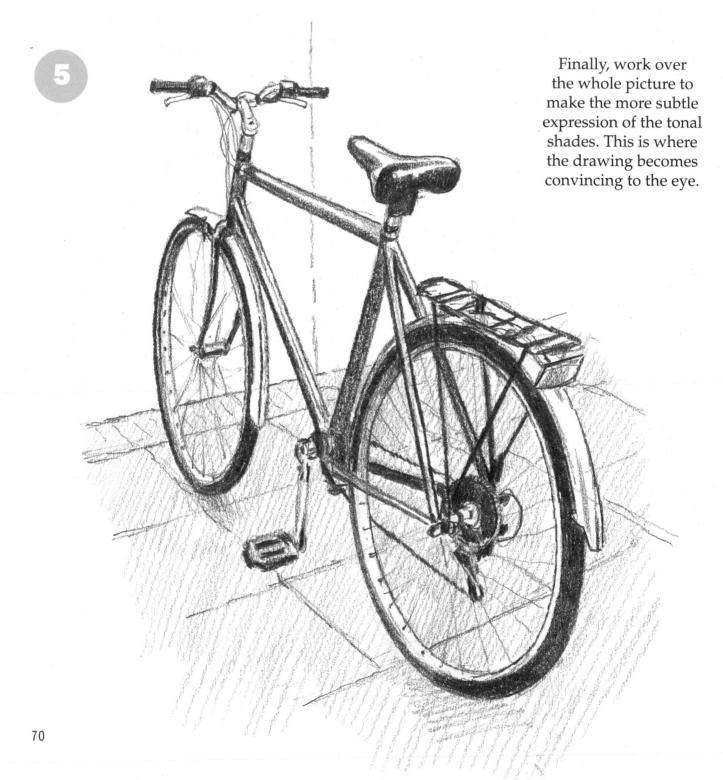

Finally, work over the whole picture to make the more subtle expression of the tonal shades. This is where the drawing becomes convincing to the eye.

 If you have a bicycle, set it up and draw your own version of this composition. The ellipses of the wheels are the hardest part to get right, but when you are successful in that respect it will really make the drawing truthful to the eye.

1

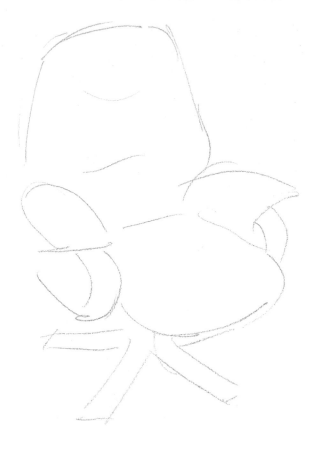

This armchair is quite a simple shape to draw and shouldn't tax you too much. The main thing is to get the proportions of the shape right from the start, and then the rest will be fairly easy. First comes a rough outline of the whole shape.

2

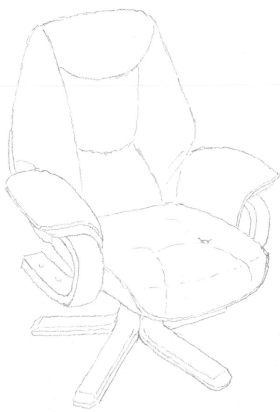

Now draw the whole shape in some detail, showing the wooden armrests and stand. There are not many interior lines or edges, so this can be done fairly quickly.

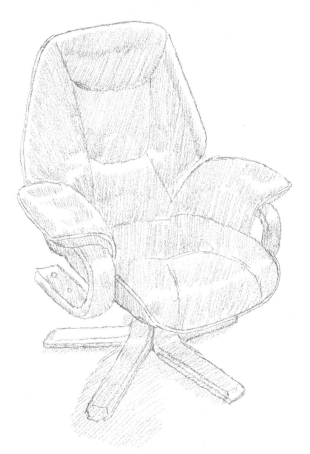

Next put in the tone lightly, not forgetting to leave the areas of the brighter parts untouched. If you shade over them by mistake, use your eraser to pick out the white areas again.

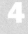

Following that, put in the darkest tones very strongly, and immediately you will start to see the solidity of the chair becoming evident.

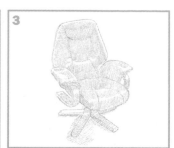
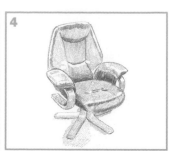

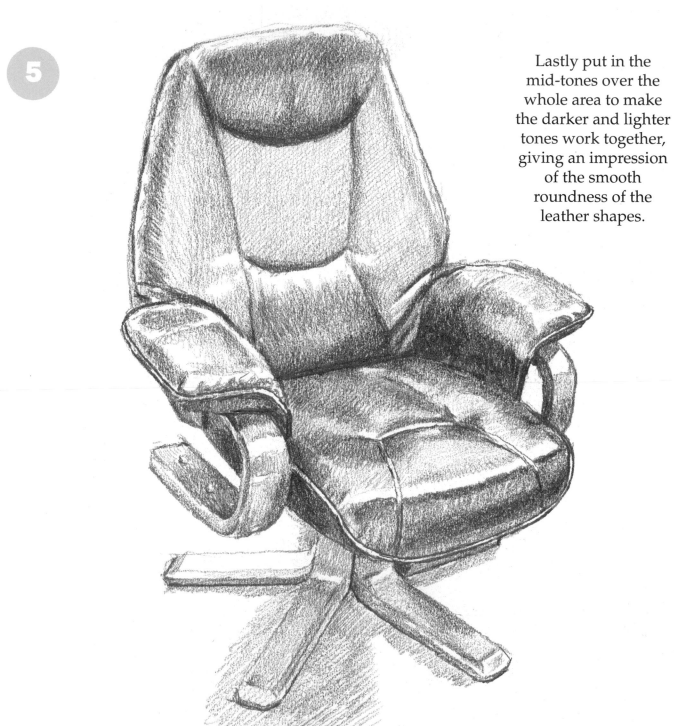

Lastly put in the mid-tones over the whole area to make the darker and lighter tones work together, giving an impression of the smooth roundness of the leather shapes.

 Draw an armchair in your home in a similar way – or, like me, you
can draw one on display in a furniture shop.

BOOKS

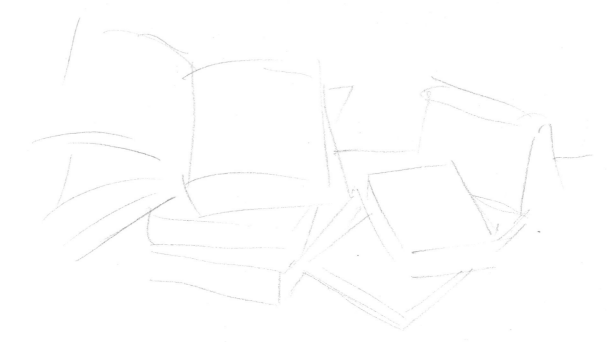

This is a rather unusual still life subject that provides plenty of interest, because it is a group of objects of similar shapes but haphazardly arranged. These books are loosely piled, with one open and one standing on edge. Start with a quick sketch, showing the shapes of the books relative to each other.

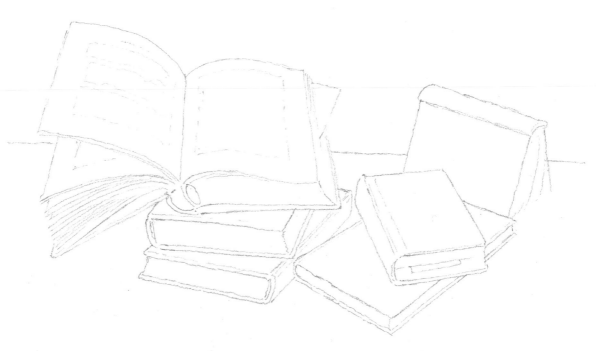

Next draw up the shapes as accurately as you can, noting the perspective effect that makes the far end of the books slightly smaller than the nearer end.

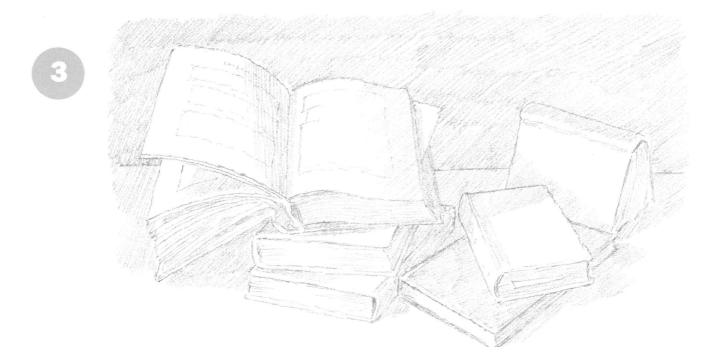

3

Now put in the areas of shading, including the cast shadows of the books on the surface of the table. Keep the tone evenly light throughout at this stage.

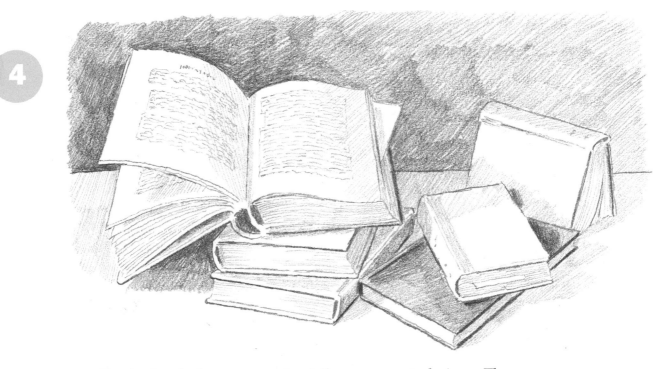

4

Put in the darkest tones where they are most obvious. These are mainly around the edges of the book covers.

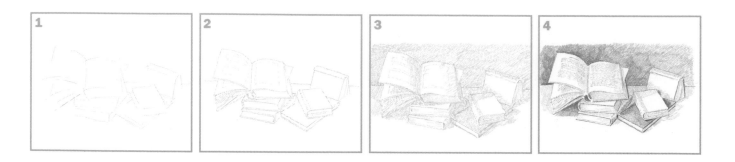

5

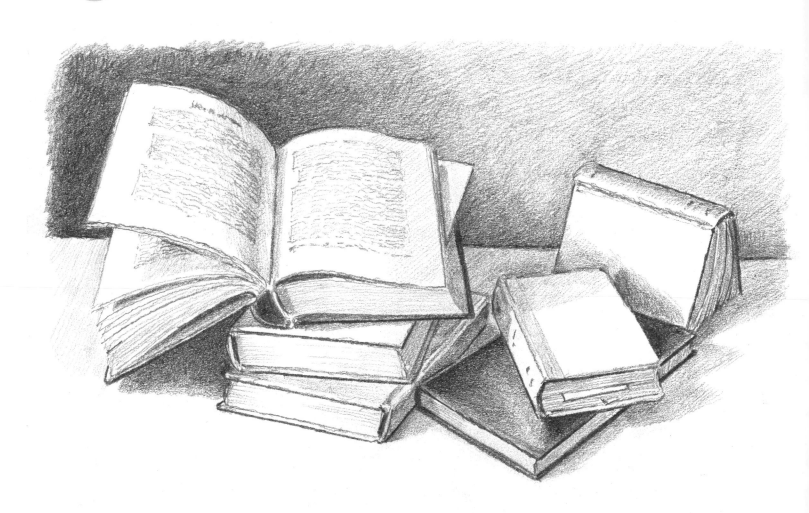

Working over the whole picture, add all the necessary variations of tone and texture to give the subtle effects of the assembled books.

 For your own composition, include only as many books as you feel comfortable with. As your drawing gains fluency you can tackle ever more complicated still lifes.

Here I took a few attractive pieces of stone and arranged them in a group. These are interesting to draw, because they all have rather different textures. As usual, draw the first marks very lightly, just to indicate the various sizes and shapes of the objects. Don't get into too much detail yet – just notice the main differences of the stones.

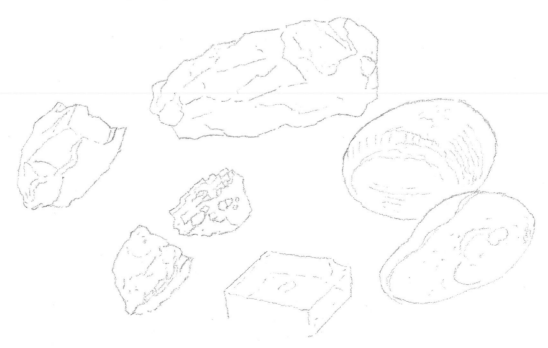

Now draw everything as accurately as you can, describing the irregular facets on some of the stones. Notice the hand-cut transparent piece in the foreground, which is carved from a larger stone but is a naturally occurring mineral.

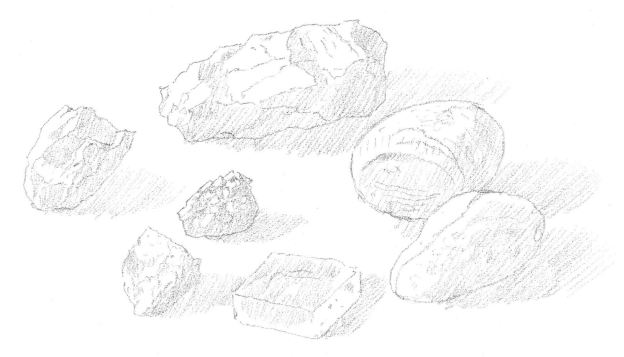

Then put in the main areas of tone so that you can begin to see the roundness or angularity of the pieces of stone. Keep the tone very light as yet.

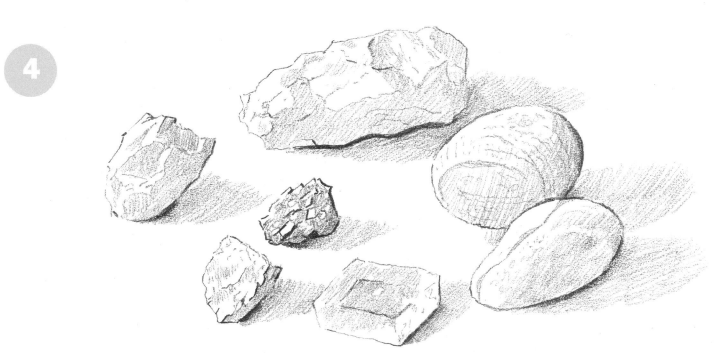

Mark in the very darkest tones – as you can see, there aren't very many of these. Most of them are where the stones meet the surface that they are lying on.

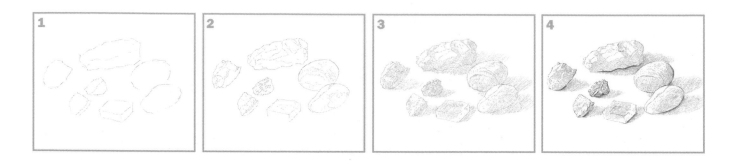

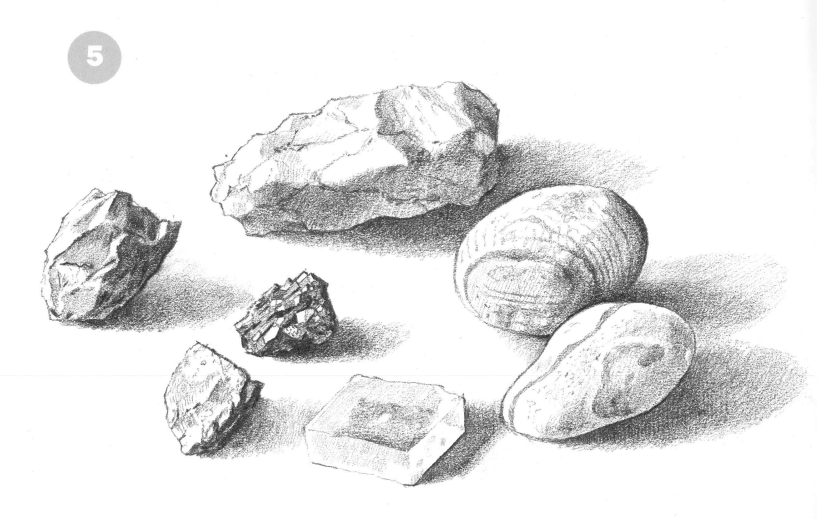

Now comes the final stage, where you need to be as careful as possible to show how each stone differs from the others. Take your time over this – you won't regret it, as getting the subtleties of each mineral texture is quite an interesting effort to make.

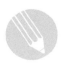 Find some pebbles or pieces of rock of various sizes and have a go at drawing your own composition. The most important thing is to show the various textures as convincingly as you can to convey the substance of the pieces.

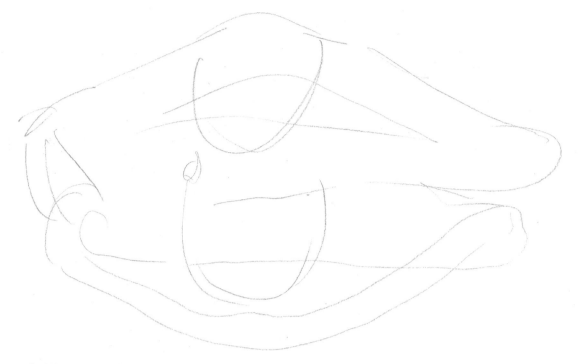

This large leather bag is not a difficult thing to draw as the overall shape is pretty straightforward, though the details of the folds are a little complex. Again, start with a loosely drawn rough outline that gets the essential shape of the object.

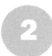

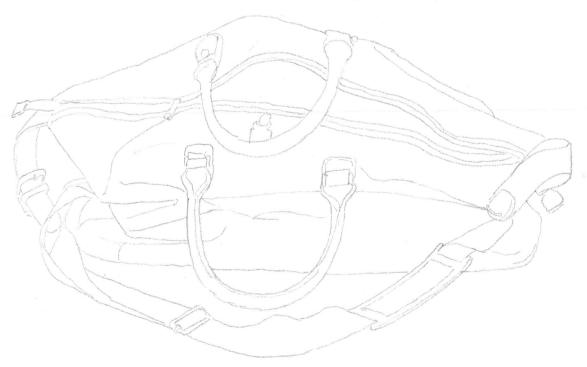

Next, carefully draw the whole outline of the bag, including the handles and straps and the main folds in the material. This is where you will most likely change and redraw quite a bit before you get it quite right.

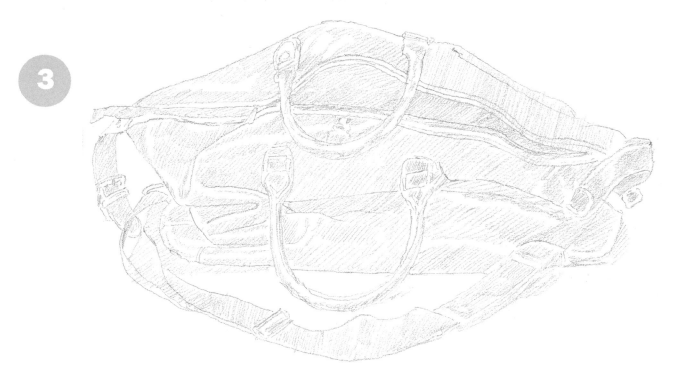

Next comes the tonal work, which is quite extensive on this object.
Make sure all the brighter highlights on the folds are left clearly
reserved as white paper.

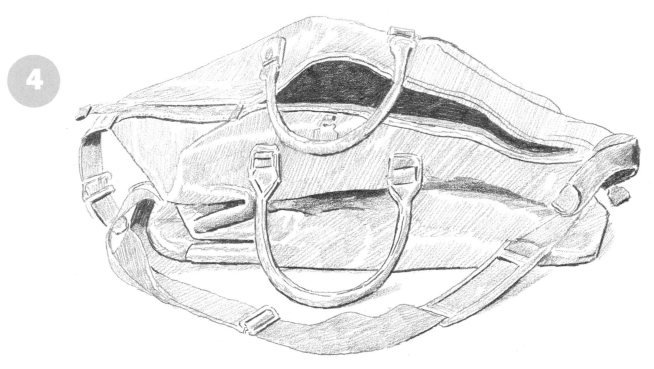

Then put in the darkest tones, which are few except for the large area
of the inside of the bag.

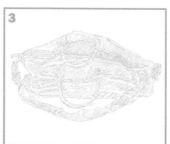
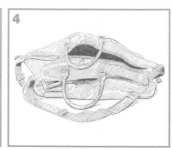

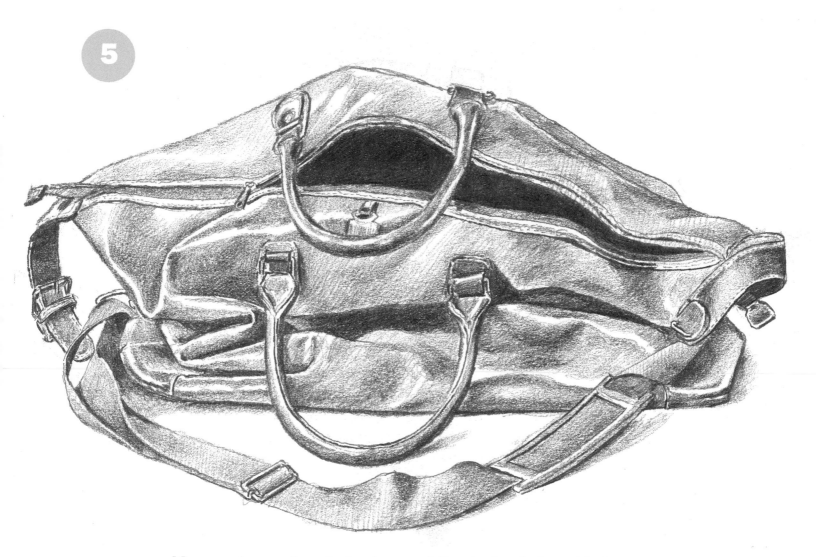

Now work over the whole piece, melding in the dark and light tones to give the effect of the leather texture. Also put in the details of the stitching where it is obvious.

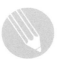 A large bag like this with all its folds and contours can be a good test of your abilities, so find one to draw from life and see how well you can do it.

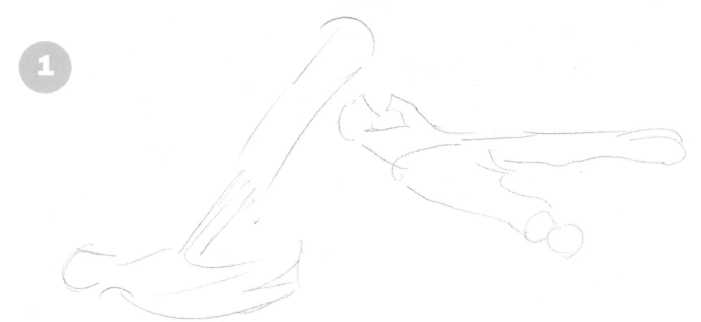

Here I have taken two items from my home toolbox to draw. They are quite difficult because of the reflections on the shiny parts of the steel, but as long as you tackle the drawing bit by bit it is not going to defeat you. First, lightly draw in lines to indicate the main shape and proportion of the two pieces.

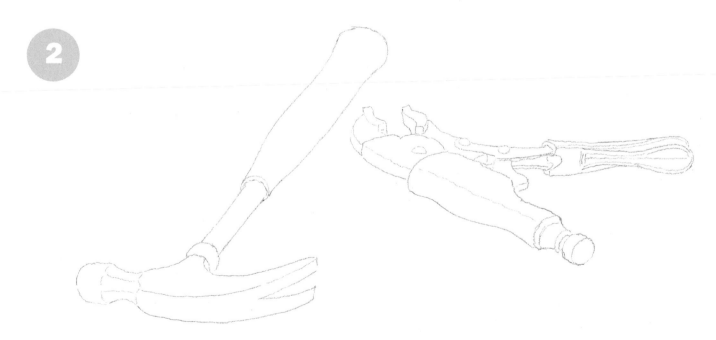

Now draw in the shapes in a precise outline, showing all the main parts. Be careful to get the tools the right length in relation to each other. The perspective effect of foreshortening should be taken into account.

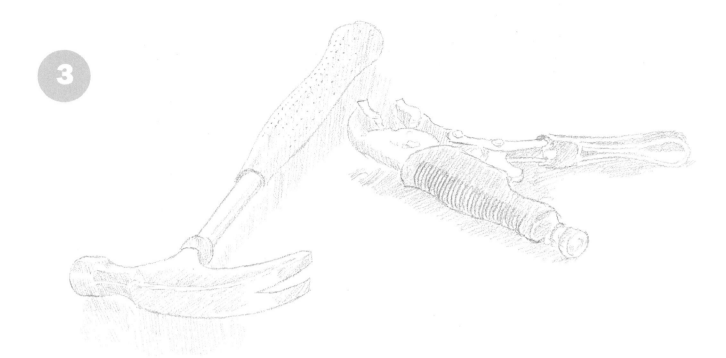

The next stage is where you put in the overall tonal areas so that you start to get an idea of the dimensions of the two objects. Include the cast shadows on the surface they are resting on.

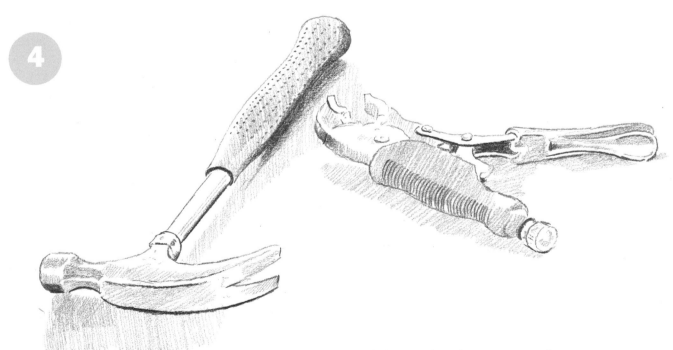

Now put in the darkest areas of tone and the areas of texture, such as the dotted marks on the hammer handle. This immediately gives a more convincing look to the solidity of the instruments.

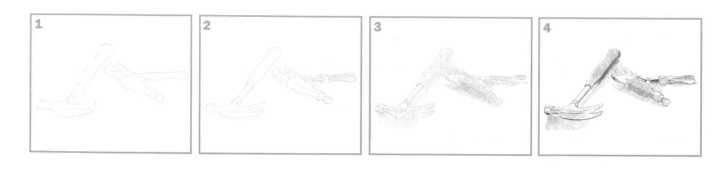

Lastly you need to go over the whole picture slowly and carefully, putting in variations on the tone and texture until you think that the tools look like the real objects. Be careful not to fill in the bright areas with any tone, or you will lose the contrast between bright areas and dark ones that indicate a reflective surface.

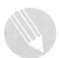 Metal tools are quite easy to find in most houses, and you should not have too much trouble in drawing them. Just remember that metal tends to show great contrast in its dark and light areas.

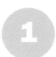

1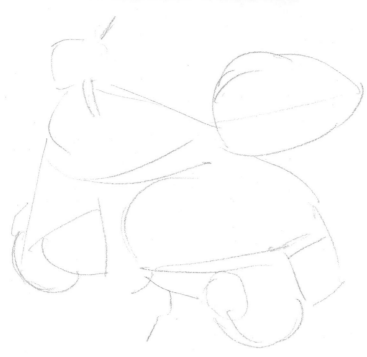

This drawing could be tricky as the parts of the scooter have to be in the right proportion to each other, but are not always easy to see clearly. Keep stepping back to check the shapes when you are drawing. First make the usual rough outline that will give you all the main shapes as correct in proportion as possible.

2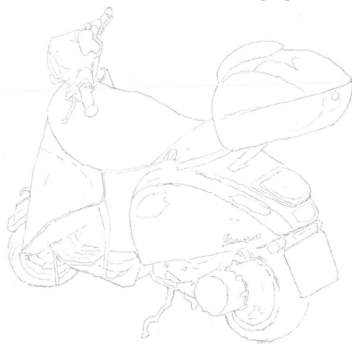

Now make a very careful line drawing of the whole scooter. It is important to get the angle of the front wheel in relation to the handlebars right.

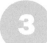

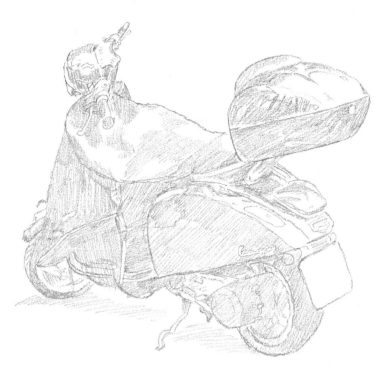

Next, put in the tonal areas in one quite light tone all over. This is quite a large area of the whole.

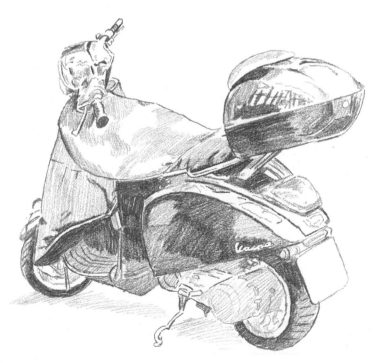

The very darkest tones come next – a solid black for those areas that seem to require it.

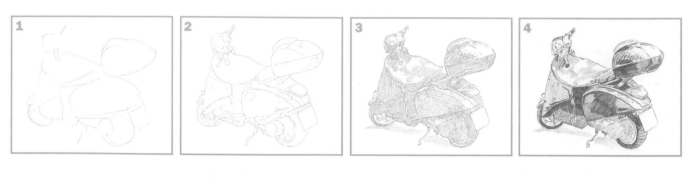

5

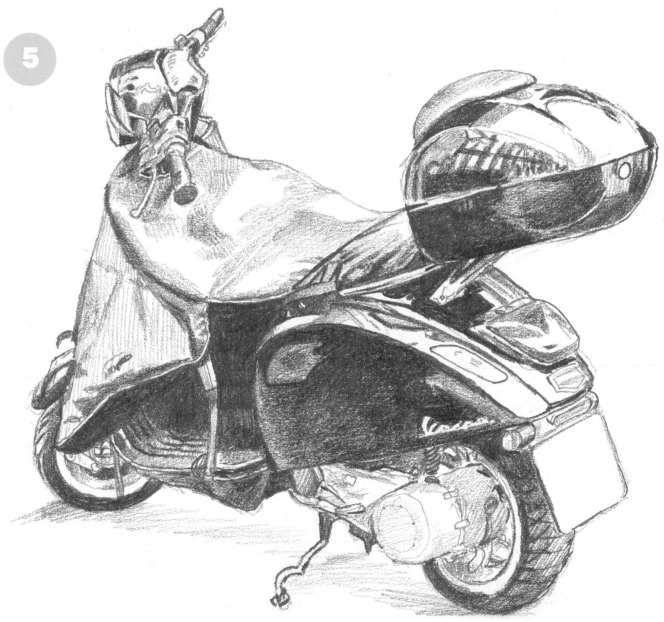

Finally, put in the hard work of making it all look as convincing in
tone as possible, showing areas of sharp contrast and other parts
with gradually blended tone.

 Once you feel confident about this drawing, find a scooter to draw from life and see if you can make it look convincingly real. With a stationary object, you have all the time you need to do it well.

A CAT

1

Drawing animals can be rewarding, but difficult if they won't keep still. You can try it when they are asleep or else work from photographs. To draw this cat, very lightly sketch in the main area of its body, head and tail just to indicate size and shape.

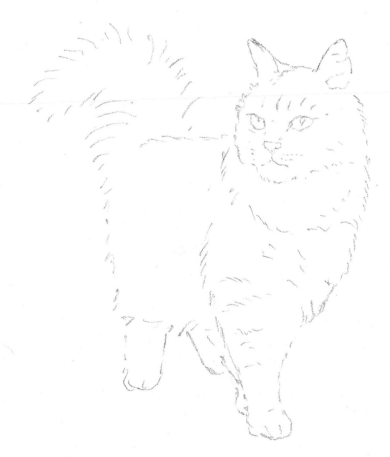

2

Then make a more careful drawing of the main outline, indicating the fluffy fur of the main shape and the legs, head and facial features.

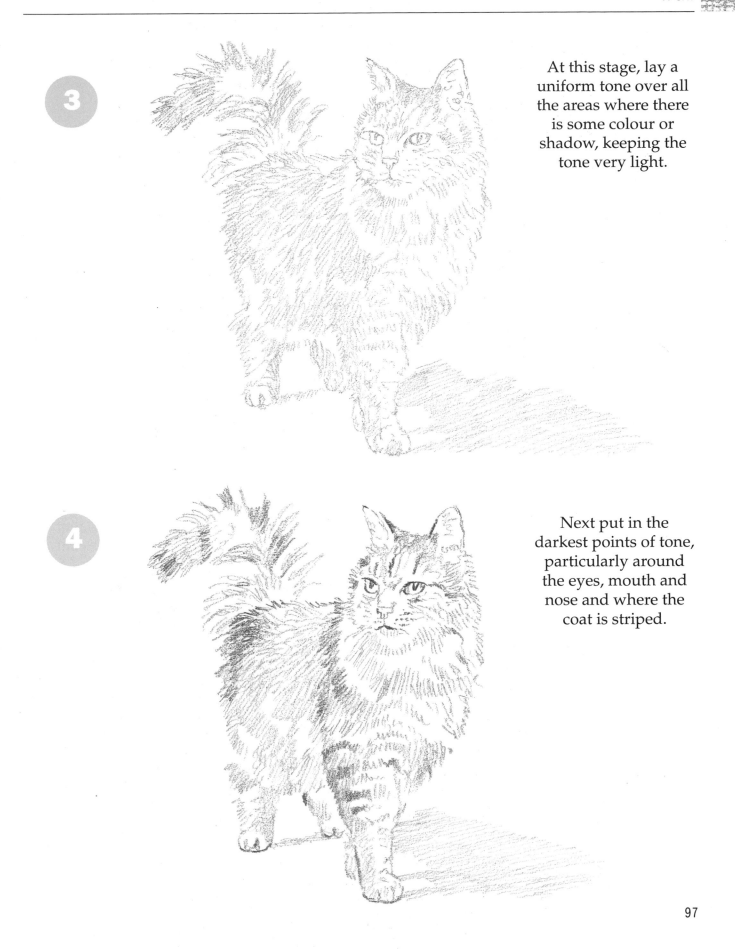

3

At this stage, lay a uniform tone over all the areas where there is some colour or shadow, keeping the tone very light.

4

Next put in the darkest points of tone, particularly around the eyes, mouth and nose and where the coat is striped.

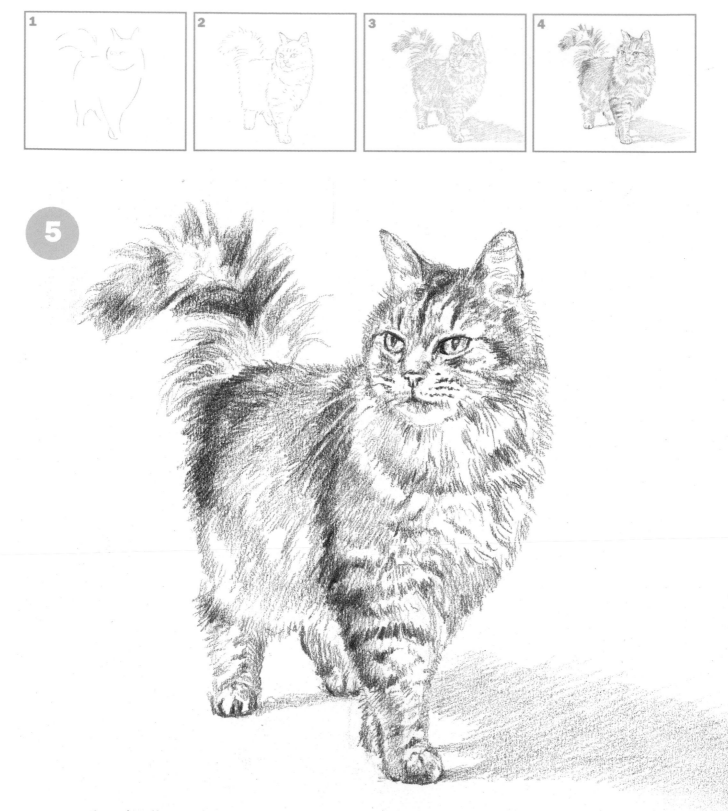

Then finally work into the tonal areas to give a better idea of the texture of the fur and the pattern of the markings. You can also soften some of the marks by lightly rubbing an eraser over them.

After this first practice at drawing an animal, find a cat or any other furry domestic pet and draw it to the best of your ability.

A PARROT

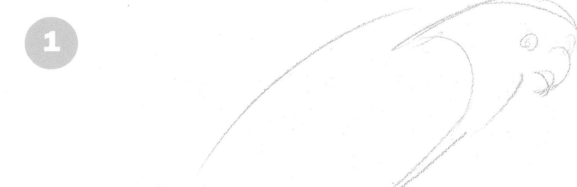

Start by getting the main shape and proportion of the bird on your paper,
using a few lightly drawn lines.

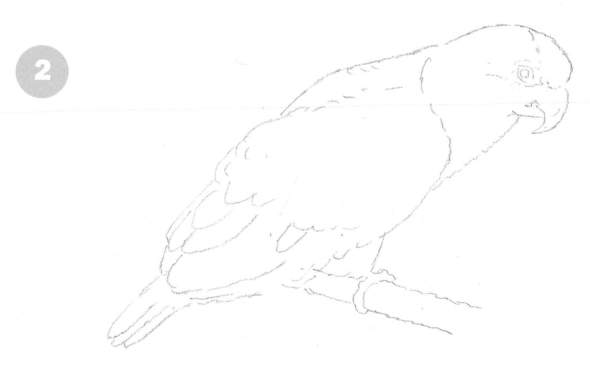

Then start to draw the whole outline shape more carefully, getting
some detail into the picture.

3

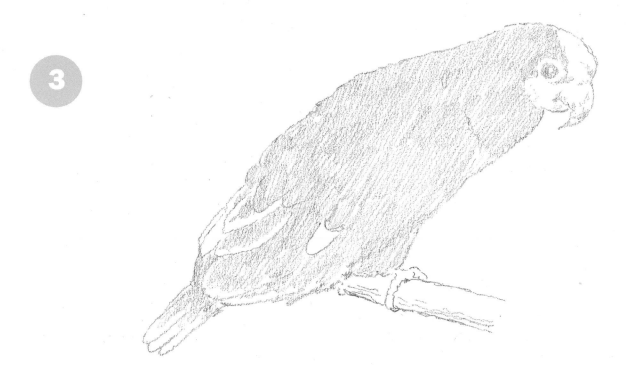

Put a layer of tone over all the areas where the colour and shade can be seen, but keep it very light at this stage.

4

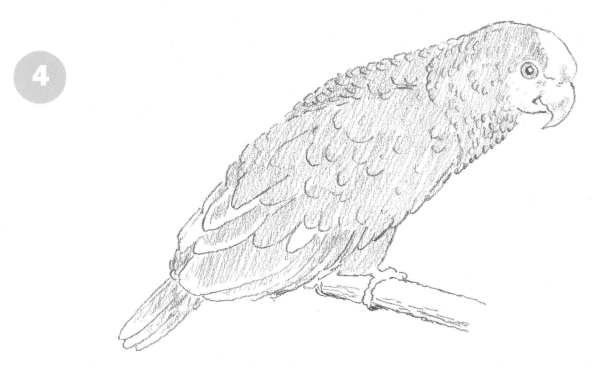

Next put in any darker tones and the texture of the feathers. Draw in the eyes, beak and claws more sharply.

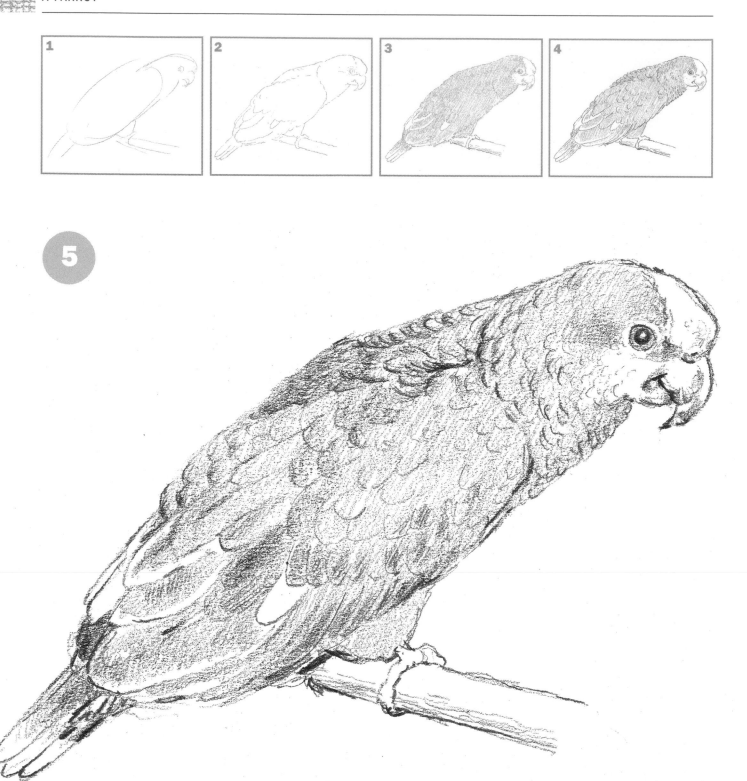

Lastly, work in the more subtle tones on the bird until you are
satisfied with the result.

 Birds are rarely motionless, so to find your own subject your best plan is probably to work from a photograph. This will also give you the chance to choose from a range of exotic birds.

A PORTRAIT PROJECT

1

Here is a drawing of one of my daughters grinning at something that has been said. Because she can't keep the smile on her face for a long time, I took a photograph and used that for most of the drawing. As usual, start with a light outline.

2

Having made a rough guide to the head, now start to draw more carefully to get the right look of the whole head and features. This is crucial if you want the portrait to resemble the sitter. The relationship of the eyes, nose and mouth is most important, so take your time on this.

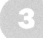

Now put in the main areas of tone, all in the same light weight.

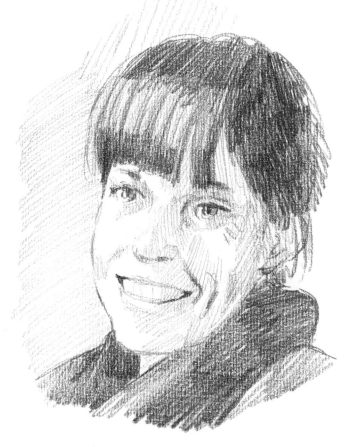

Next come the darkest tones, such as the hair and the eyes and in this case the clothing.

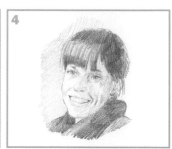

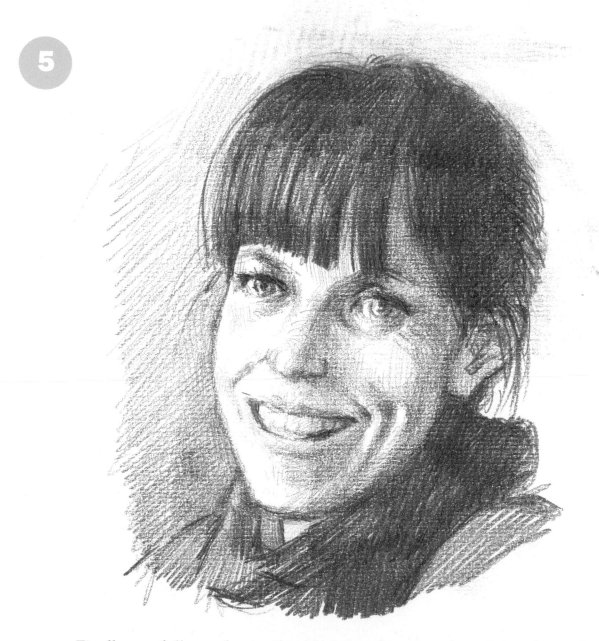

Finally, carefully work over the whole head, getting the subtle relationships of light and shade as accurate as you can. Allow quite a bit of blending of tones to render the features soft and human.

 A portrait is easier if the sitter is not smiling, but the resulting drawing will be less lively. Expressions are fleeting, and catching them is tricky – but just observe the face carefully, especially around the eyes and mouth.

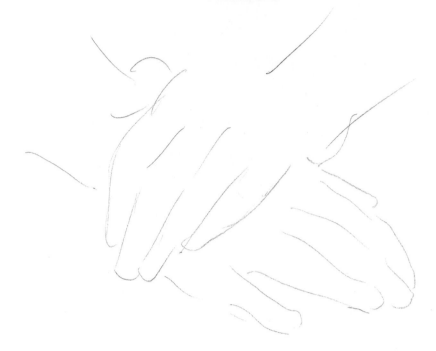

Here are a pair of hands, lying on someone's lap. Draw in the main shapes very simply in order to get the proportion and shape correct.

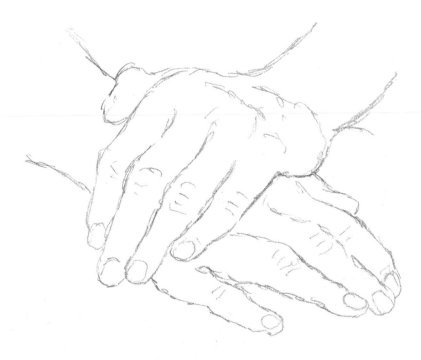

Now, with a gently sensitive line, make sure that all the shapes of the fingers, back of the hand and wrists are drawn. Mark in the creases on the knuckles.

With a slightly scribbly texture, put in the main areas of shade,
including the darker background area.

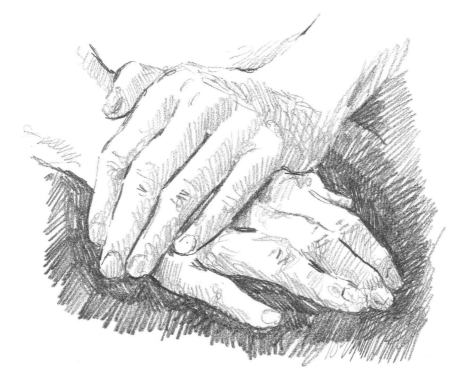

Next mark in very definitely the dark tones noticeable in between the
fingers and in the background.

Lastly, gently work in the in-between tones so that the hands start to become more rounded in shape.

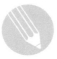 Next you need to try a drawing from life. Look carefully at the hands as they are quite complex to draw correctly.

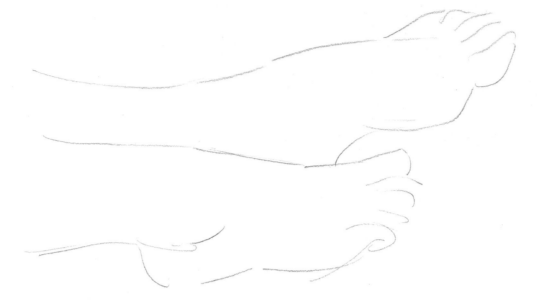

This pair of bare feet belonged to a friend of mine who didn't mind sitting for a while so that I could draw them. For a drawing from life you will need to persuade someone to sit for you, unless you draw your own feet in a mirror. First, draw in the main shape of both feet here and their position.

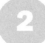

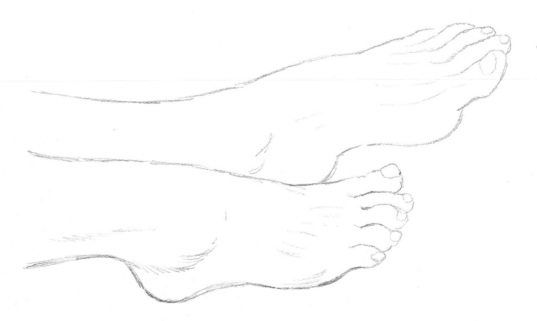

Now, more carefully, draw the whole outline shape of the feet, without worrying about any tonal values. Alter any shapes that don't seem right to you.

3

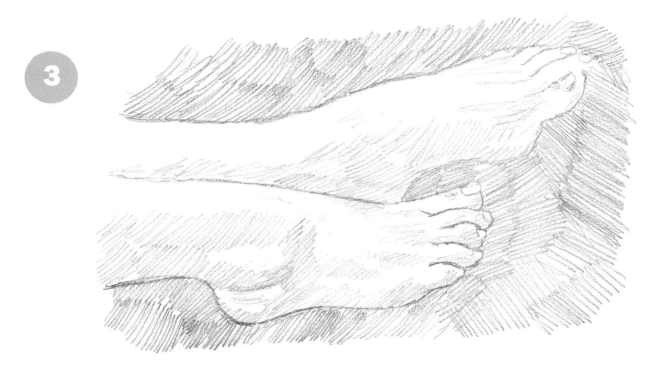

Put in a light tone all over the feet to show where shadows appear, reserving white paper for highlights. This helps to give them some three-dimensional form.

4

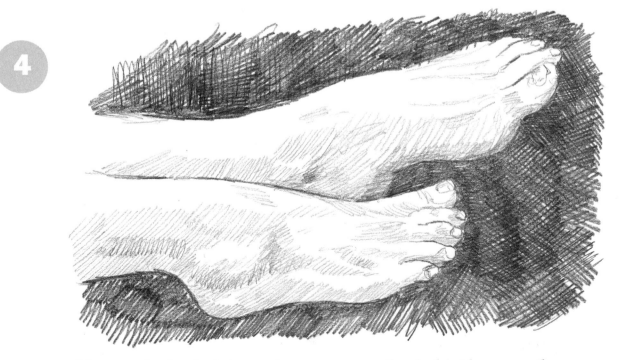

Now put in the dark tones. As you can see, the darkest here was the area of the background, the feet being fairly well lit in contrast.

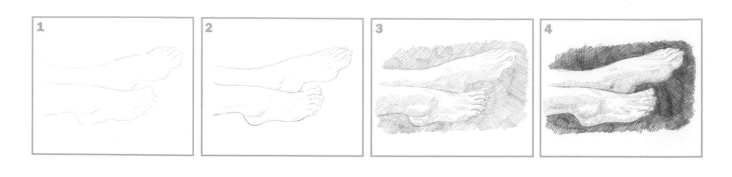

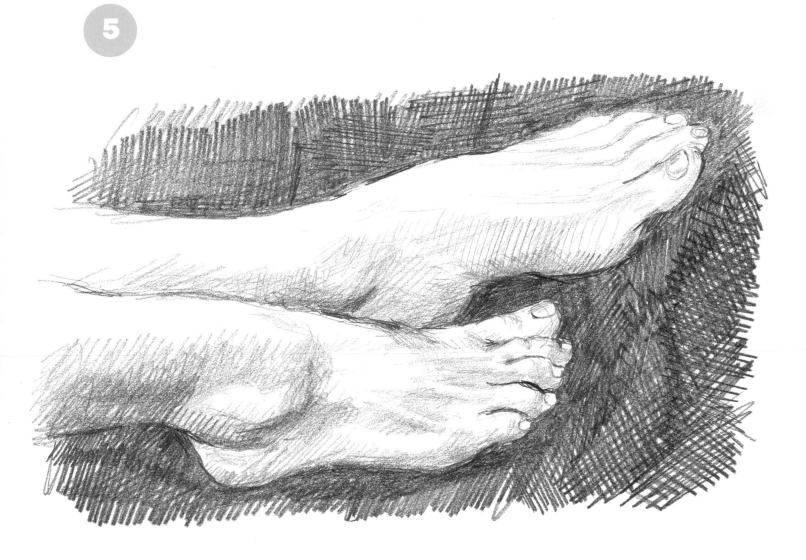

Now work over the whole picture, enhancing the quality of the tones and the edges of the feet. You may want to soften the background by building more tones over it, or by smudging the tone with a paper stump. You can buy these in most art shops.

 When you make a drawing from life, look carefully at the feet in front of you, because all will have their own particular shapes. Older feet will look rugged, and younger feet will be smoother.

A PROFILE PORTRAIT

1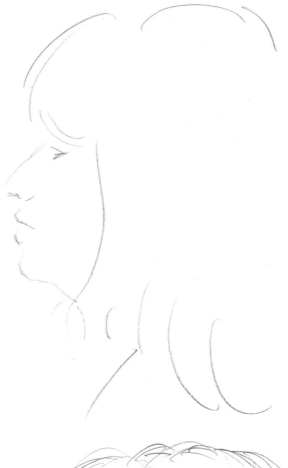

A profile, or side view, is easier than a full-face portrait, because the nose is simpler to draw and only one eye is visible. Draw in the main shape loosely and note that the height and width of the head are the same size from this angle. The eyes are about halfway down the length of the head and the end of the nose is roughly halfway between the eye and the chin.

2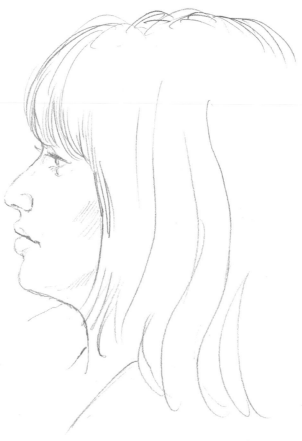

Now begin to draw in the main outline of the face and head. Notice very carefully the exact shape of the nose and whether the upper and lower lips are both protruding the same amount or if one protrudes further than the other. Also, how does the angle of the chin look in relation to the mouth and nose?

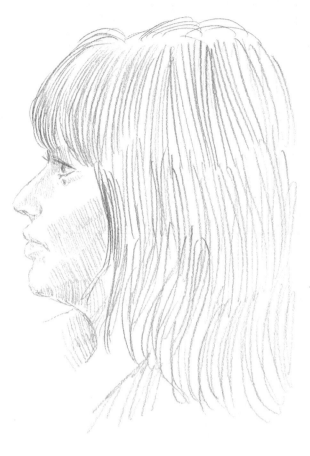

Now start to build up tonal and textural values on the face and hair. Keep all the marks fairly light at this stage.

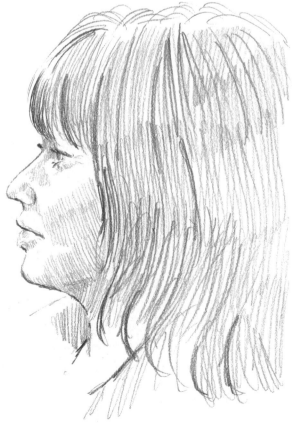

Next work in the darkest marks, especially around the eye, the end of the nose, the mouth and the lower chin. The hair can also be darkened at this stage.

 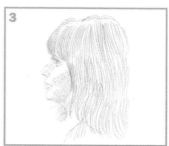 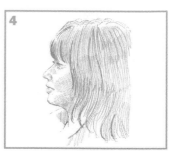

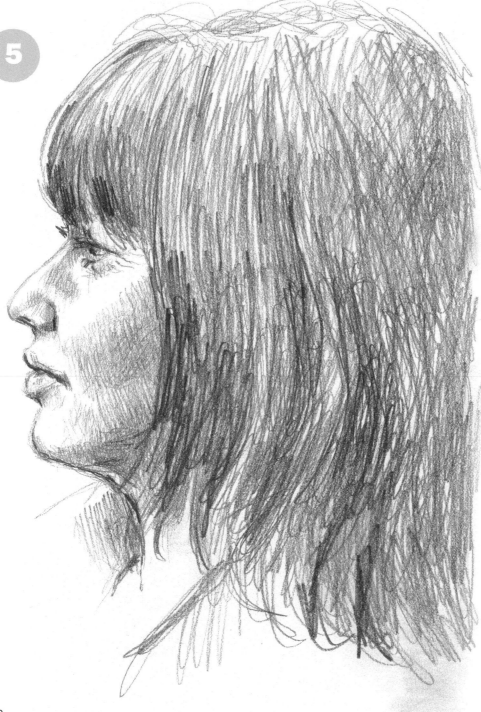

Lastly work over the whole portrait, building all the mid-tones and increasing the texture of the dark hair. In my picture the light is overhead, so the darkest area of the hair is in the lower part.

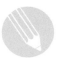 Following this, have a go at drawing a profile by yourself. To make it resemble the sitter you will have to take care to get the shapes of the eye, nose, mouth and chin right. Look at the whole head, not just the face, since people have characteristic head shapes too.

1

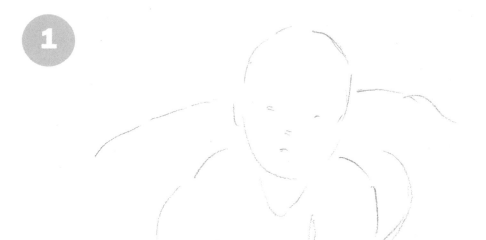

Drawing a very small child is not easy, as they only keep still when they are asleep. I chose to take a photograph of my youngest grandchild while she was playing in a blow-up cushioned ring. She was very interested in my efforts to get her picture and stared at me intently. First, make a light sketch of the shapes of her head and arms and the cushion around her.

2

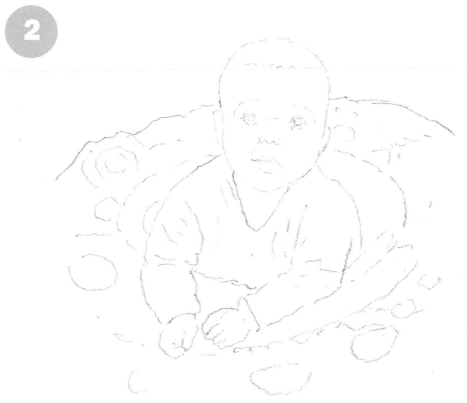

Next, draw a careful outline of those shapes and the surroundings. Keep the lines very light at this stage and erase mistakes where necessary.

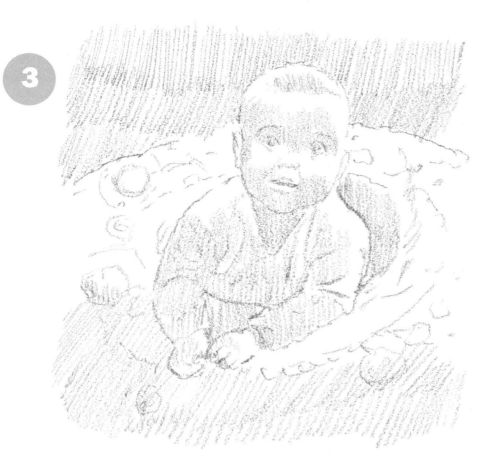

3

Now put in the areas of tone that are quite extensive, again keeping your pencil marks very light.

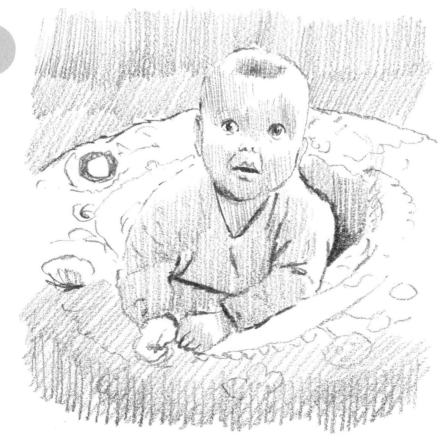

4

Put in the very darkest tones, which are not extensive in the circumstances of this composition. The light wasn't very strong, so the shadows are not dramatic.

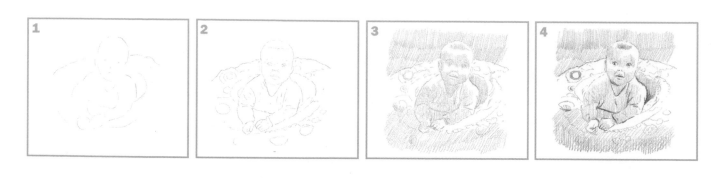

The last stage is to harmonize the tonal differences. At this age the features are less distinct than in older children and all the shapes blend in as the surface is so soft.

 After this practice piece, try a study from life. Drawing a child of under one year is one of the hardest things you can do, so don't be surprised if your first attempt isn't entirely to your satisfaction.

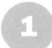

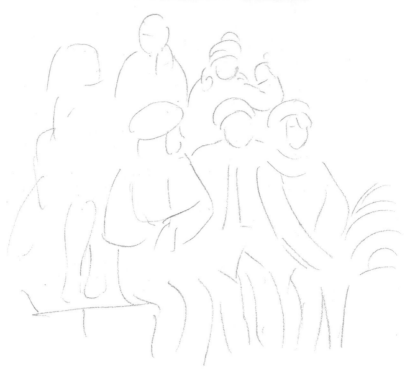

Here is a family group posing for a photograph. First of all, draw the main shapes to make sure that they will all be in the right proportion to each other.

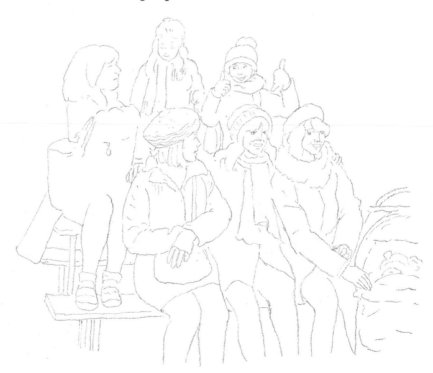

Next, draw in all the outlines of the figures without going into a lot of detail. Several of the figures are wearing dark clothes, so quite large areas have few visible contours.

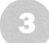

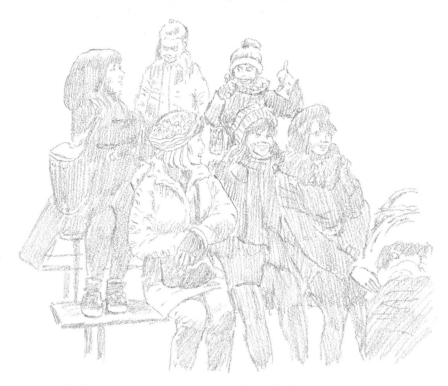

Next put in all the areas of tone over the whole composition to gain some idea of how the tonal values will look. Don't use heavy tone at this stage.

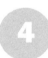

Now put in the very darkest tone, gaining a better idea of the structure of the figures under their heavy winter clothing. As you can see, some areas look much darker than others.

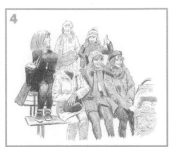

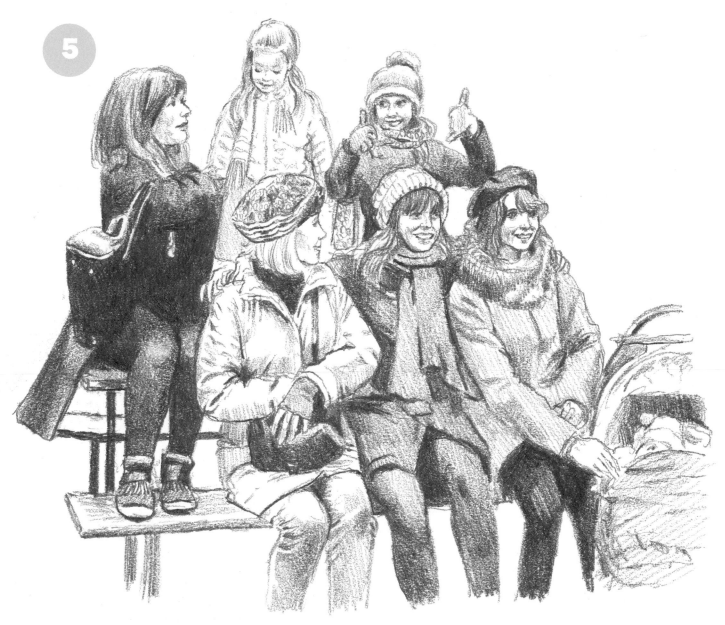

Now make a more refined rendering of the forms and textures of the scene. Do not put a lot of tone in the faces, because at this size they are too small to accommodate much detail.

 Next, have a go at drawing a group of people you know. You may find it easier to draw each one individually and then fit them together, or you could take a photograph like I did and draw from that. If you don't feel confident of your skill you can trace around the photograph, as long as you have printed it up large enough, but it's better practice for your drawing skills to copy it.

1

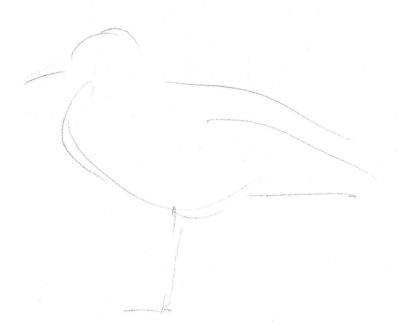

Unlike most birds, seagulls sometimes stand still for long enough to make a good subject. Even if a bird moves away another similar one will probably be close by. Start with the usual very lightly marked drawing.

2

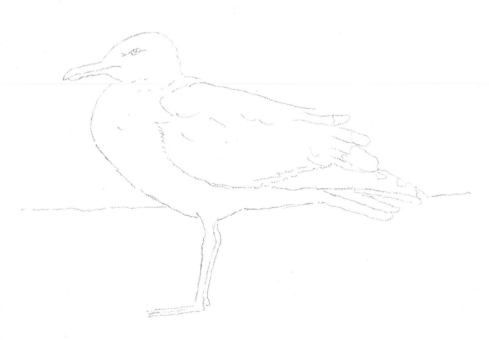

Then make a more accurate outline so that you have got all the main parts indicated in the drawing.

Next, put in the main areas of shade with an evenly light tone.

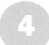

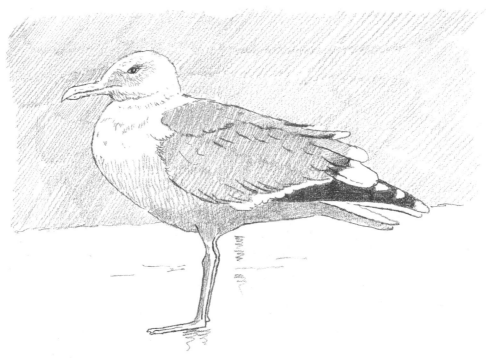

Then turn to the very darkest tones, which are mainly some of the edges and the very dark wing and tail feathers.

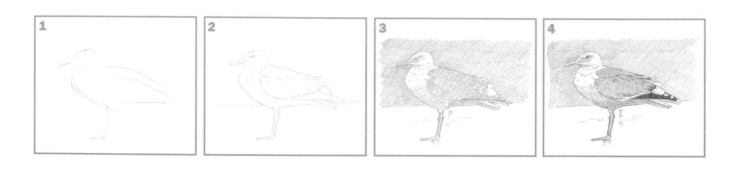

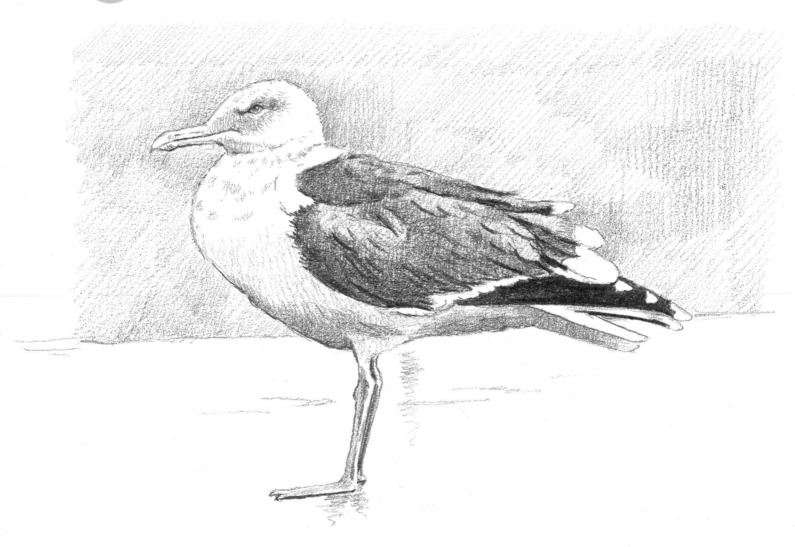

Finally, work carefully over the whole shape, putting in all the
variations of tone as accurately as you can.

 To push your skills further, find a location where gulls congregate and see what you can do when working from life.

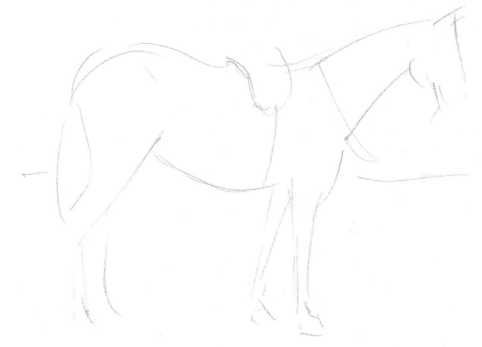

As usual the first stage is a simple sketch showing the size and proportions of the horse's shape, here seen from a side view.

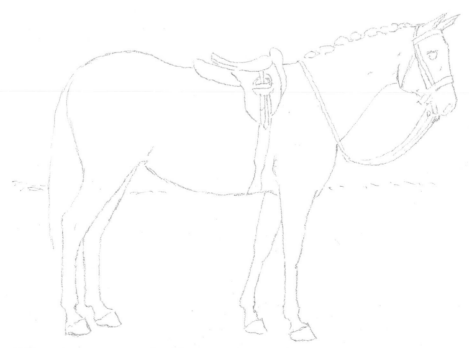

When you are satisfied by the shape, draw in the outline in some detail, making all the corrections necessary as you go along. The more accurate you are at this stage the easier the final work will be.

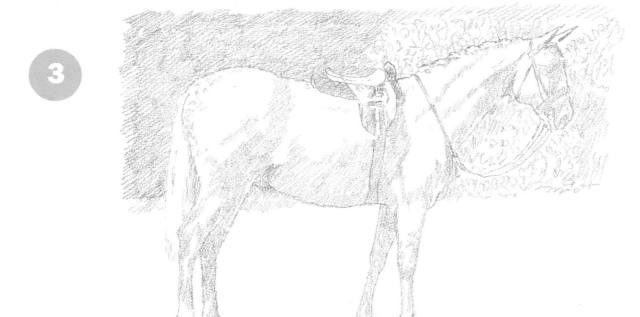

Next put in all the tonal areas with a very lightly drawn tone,
including the cast shadow and the background area.

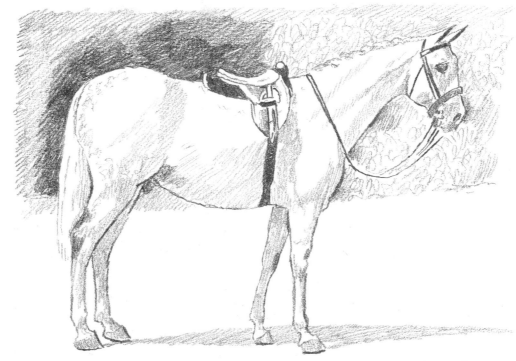

Now mark in the darker tones, such as the saddle and bridle and in
this case some of the background.

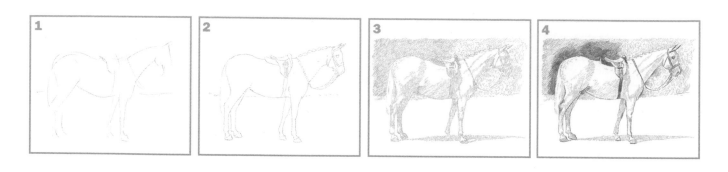

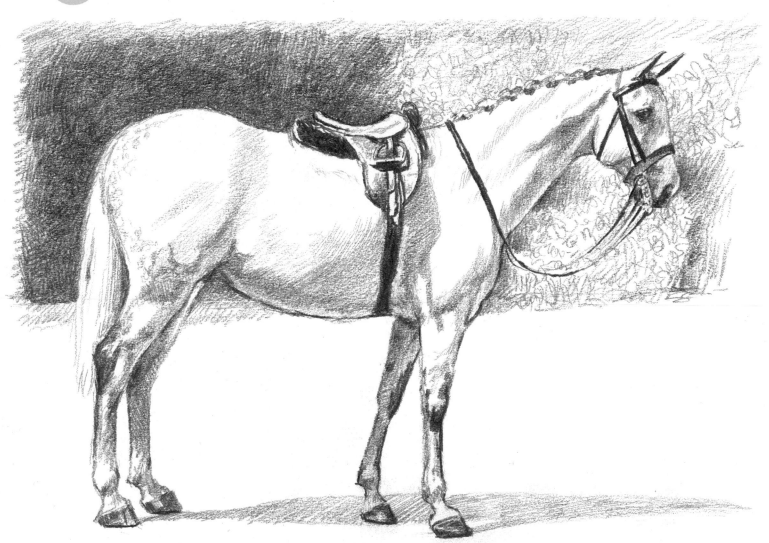

Lastly, working over the whole picture, graduate all the tones to
describe the contours of the horse's body.

 To find more equine subjects, ask permission to draw the horses at a local stables. If you cannot complete a drawing, take a couple of photographs so you can finish working on it at your own pace.

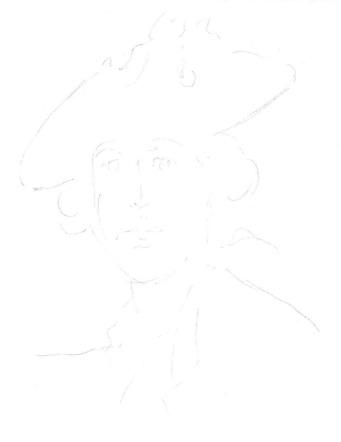

1

One method of improving your skills is to copy the work of acknowledged master artists. The painting I have chosen here is a 1756 portrait of Captain Robert Orme by Joshua Reynolds. It is a typical 18th-century flamboyant style of portrait with dramatic lighting. Begin by drawing a rough outline of the head.

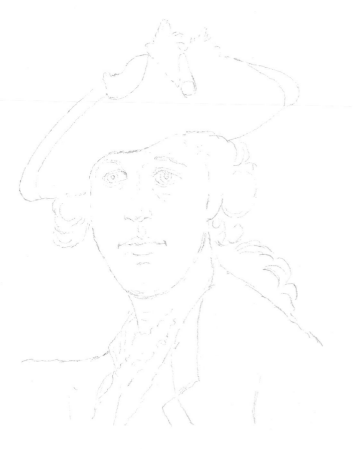

2

You will need an outline drawing in some detail before you move on. Making a tracing of the finished drawing here is one way you can ensure that your proportions are exactly correct. This isn't cheating – many artists do it when they can.

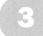

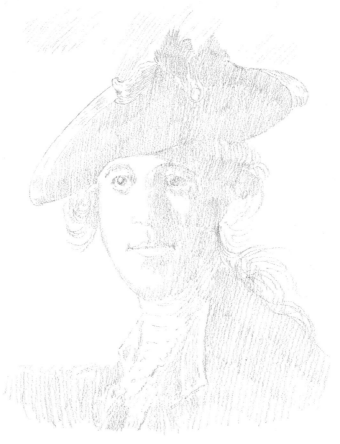

Next put in the areas of shade, all in the same light tone. Be careful to leave a white space in the eyes to act as a highlight near the pupil.

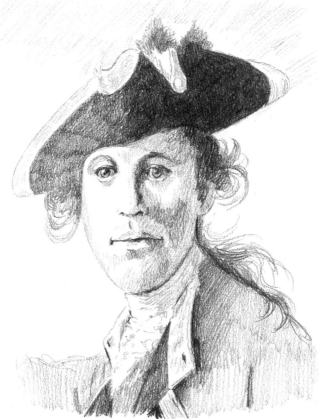

Now put in the darkest areas of tone, especially on the hat, eyes and mouth.

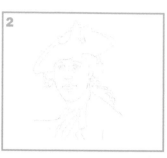
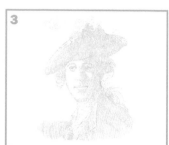
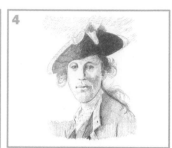

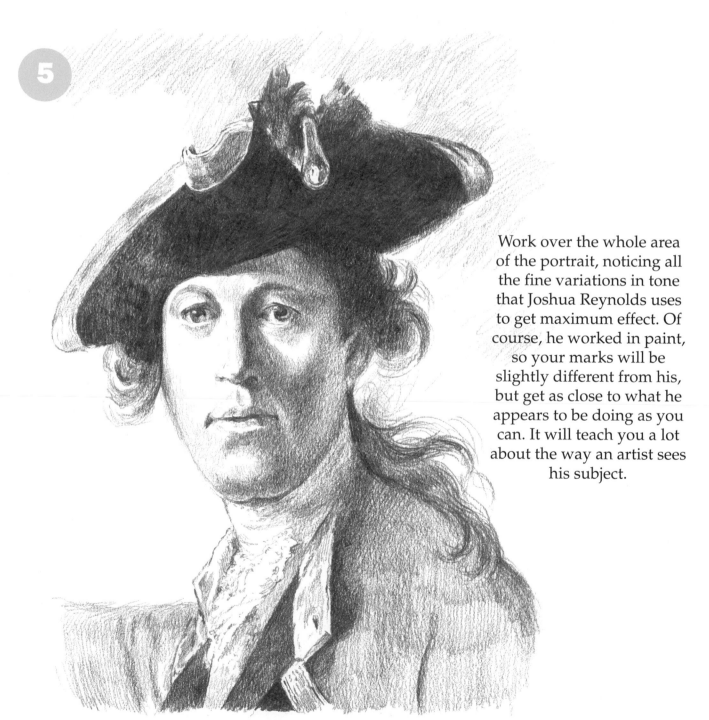

Work over the whole area of the portrait, noticing all the fine variations in tone that Joshua Reynolds uses to get maximum effect. Of course, he worked in paint, so your marks will be slightly different from his, but get as close to what he appears to be doing as you can. It will teach you a lot about the way an artist sees his subject.

Following this, try to emulate the expertise of your own favourite artist. It will help to make your drawing the same size as the print you are using for reference as you can make a tracing to see how accurate your version is.

1

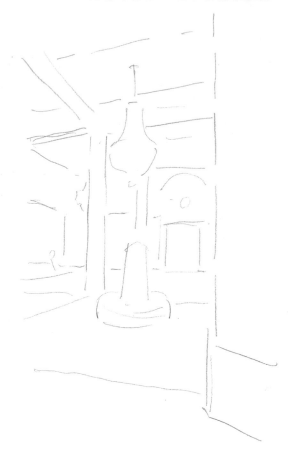

This interior is to be found in an old hotel in the main thoroughfare of San Francisco. It is the main vestibule of the ground floor, and is styled in a grand mid-20th-century manner with a large series of chandeliers lighting it. Begin by marking in the main structures of the architecture and furniture.

2

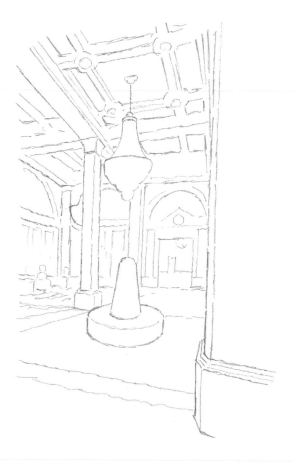

Now put in all the shapes of the walls, pillars, lighting and furniture in a more carefully drawn line. This stage of the drawing is most important as the whole effect of the final piece depends on how well it is done, so take your time here.

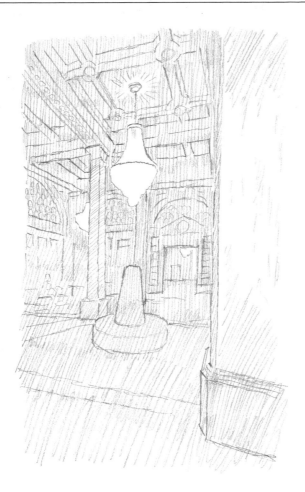

Now put in the main areas of tone. You will immediately notice how much tone there is all over the area, with only the chandelier lights and the nearest pillar edge as highlights. The whole effect is one of shadow with a couple of bright points.

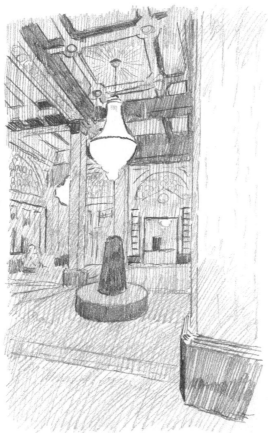

At this stage you need to put in the darkest tones, especially on the ceiling and on the furniture. Darker tones around the lights will make the light area look even brighter in contrast.

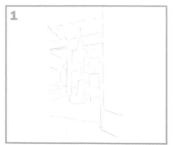
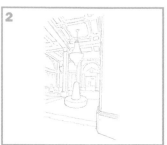
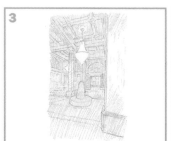
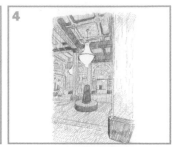

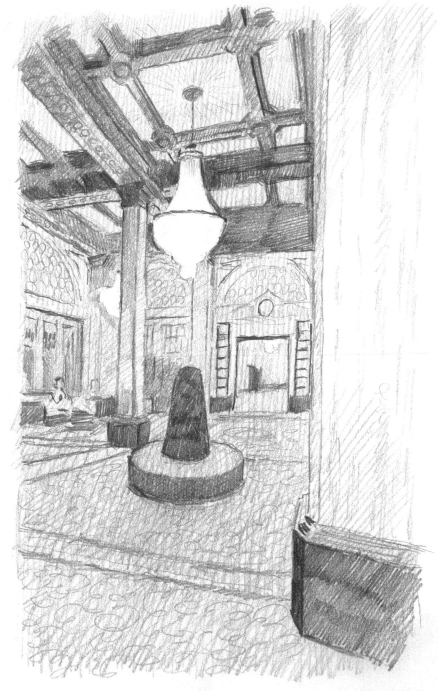

Now work over the whole scene, blending tones where necessary, and building texture on the carpeted areas and the decorated wall space. Continue until you think you have really got a good depth and tonal range to the picture.

 Try drawing a range of interiors yourself, ranging from simple to ornate. They will give you plenty of practice at describing man-made structures and forms.

1

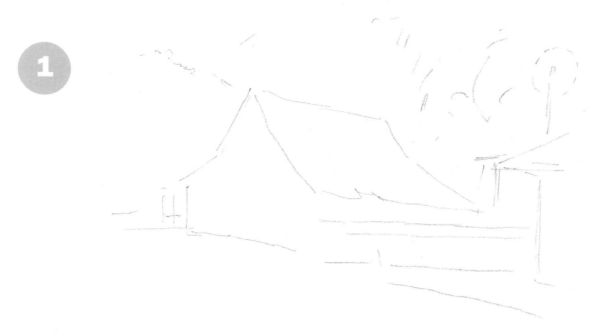

This project combines architectural structures with softer natural forms. The first step is to get the main shapes sketched in to place everything correctly on the page.

2

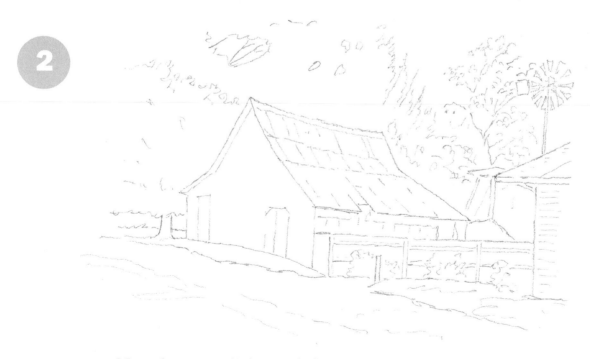

Now draw, in a light single line, everything that you can see, very simply, without much detail. At this stage you need to put in all the information that guides the rest of the drawing.

3

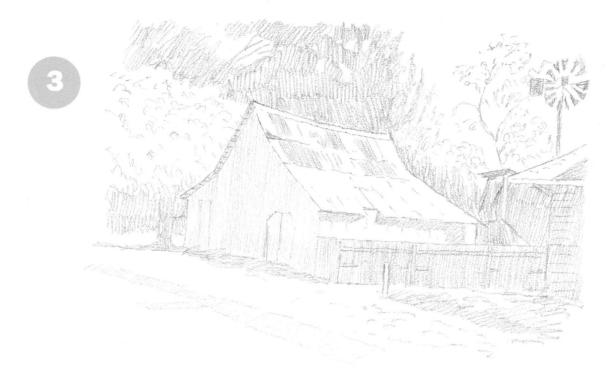

Next is the laying on of an all-over light tone to show where the shadows are. This was easy for me, drawing from life, because the sun was strong and all the shadows were fairly well defined.

4

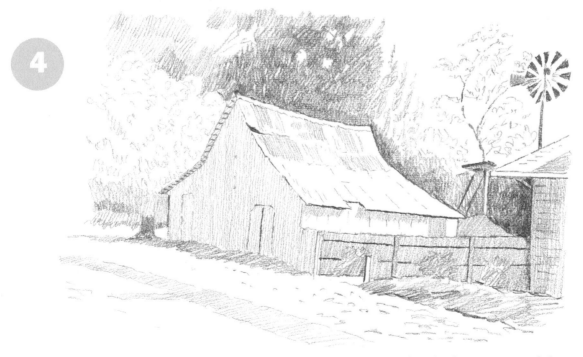

Now you need to get some idea as to how the darkest parts of the scene contrast with the light and define the depth of space. At this stage don't overdo it, putting in only the very dark tones.

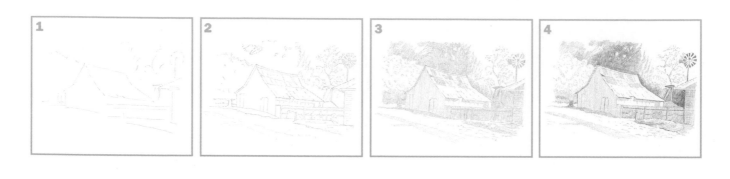

5

Finally, build up the medium tones to bring more reality into the
balance of light and shade. Also add textures, such as the leaves on
the trees and the ground.

 You are now ready to do your own outside drawing, preferably of something close to home and familiar. The impression of space is important, so devise ways of helping this to show, by the use of tone and perspective lines.

A TABLE AND CHAIRS

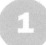

Outside my local café stand tables and chairs made of flat iron parts. Although the shapes are clear, the crisscrossing of iron pieces is a bit bewildering to the eye. Make sure that you have a simple set of marks that define each piece of furniture.

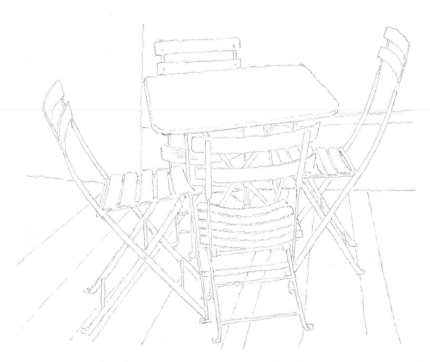

Now comes the most difficult part – drawing all the outlines of the ironwork as accurately as you can. Take plenty of time over this, because it's easy to get the various parts confused with each other.

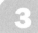

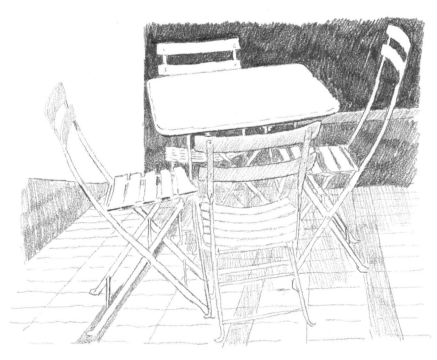

Put in the main areas of tone, which are mostly on the background and the pavement. Notice how a few parts of the ironwork are also in shadow.

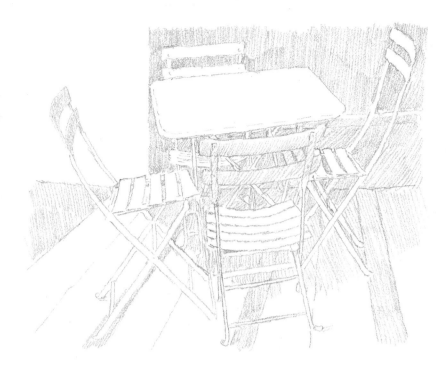

Now put in the darkest tone. This is simply the background wall and one or two edges.

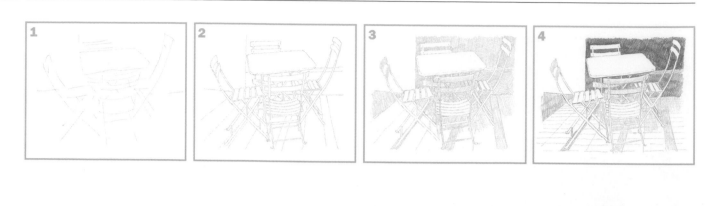

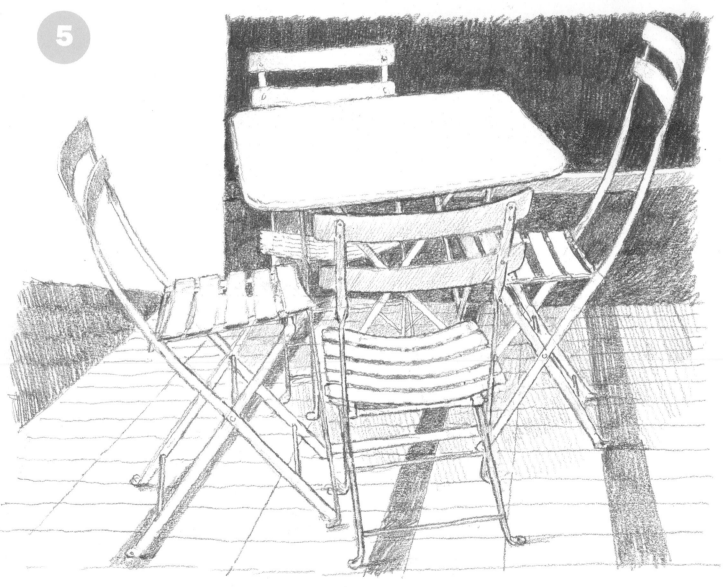

Now work over the whole picture until you feel you have got a good feeling of the scene. Take extra care where the legs of the chairs and the table cross over each other.

 Follow this by drawing various arrangements of furniture. It is sometimes easier to take a photograph first and then check your drawing against it to see how you are progressing.

A GARDEN SCENE

1

With a quick sketch, get an impression of the main shapes of the large trees, the hedge and gate, and the nearest groups of plants. This should be very lightly drawn so that you can erase it easily later on when you have a stronger line put down.

2

The next stage is to draw as accurately as possible all the main outlines of the hedges, plants and trees, and even some of the edges of the clouds. This should be done very lightly.

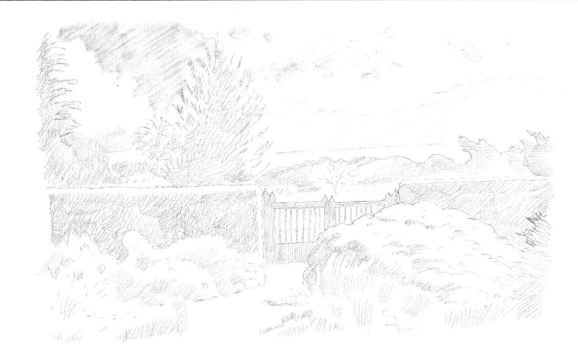

Put in the main areas of shade, including the blue sky, keeping your marks very light in tone. Smudge the areas of blue sky with a paper stump to get an even softer effect of tone.

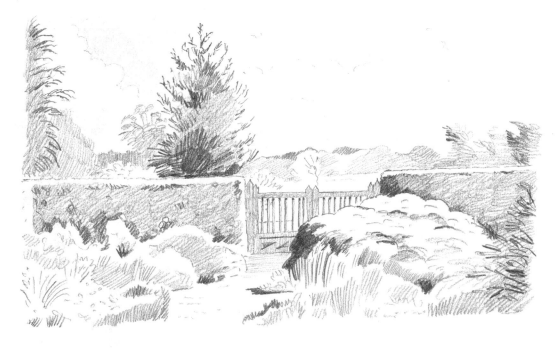

Now put in the darkest shadows, which will begin to give the picture more solidity and depth. Notice that the nearer parts appear much darker than those that are further away.

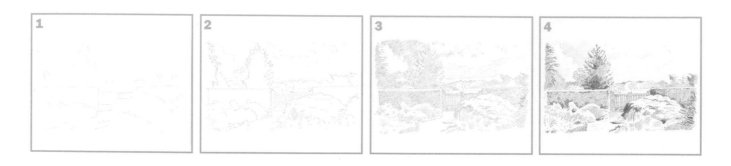

5

Now, working over the whole composition, make the tones merge
into each other where necessary, softening some of the contrast to get
the maximum effect of texture and depth.

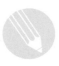

If you have a garden with plants and other features, even if it is small, it will make for a good scene. Choose your viewpoint with care, because this will help to give a more effective composition to draw.

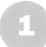

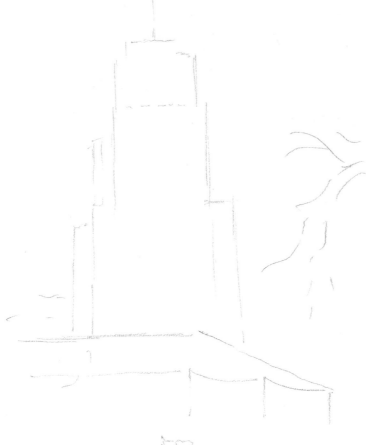

This is a drawing of a building in the main part of San Francisco which struck me as being very typical of skyscrapers of a certain period. Start your own drawing by sketching in the main bulk of the skyscraper with suggestions of the foreground building and tree branches nearby.

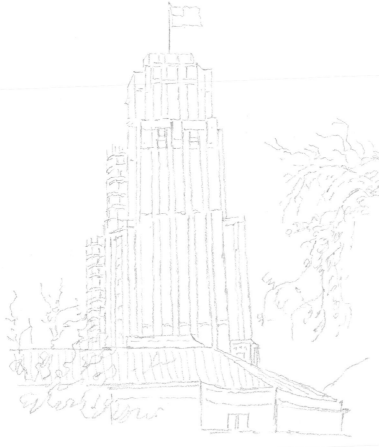

Then carefully mark in all the main shapes of the building including the large Stars and Stripes flying from the top. The sea breeze from the bay extended it nicely for my picture.

3

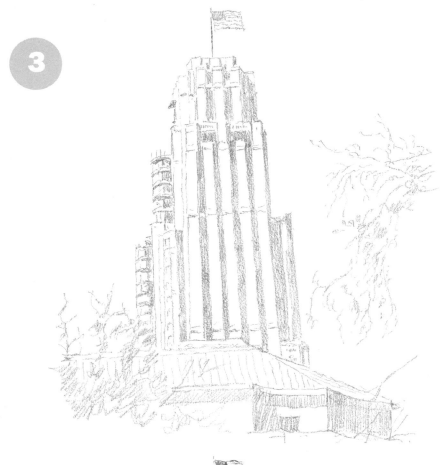

Put in the main tonal areas of the scene, keeping them all quite light at this stage. Draw in the tree branches that cut across the picture in more detail.

4

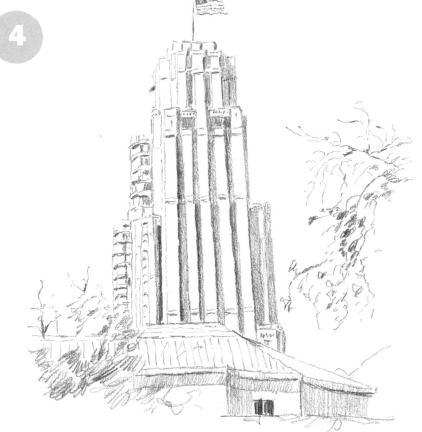

Next, put in the very dark parts where the shadows are strongest. In this drawing they are only minimal.

157

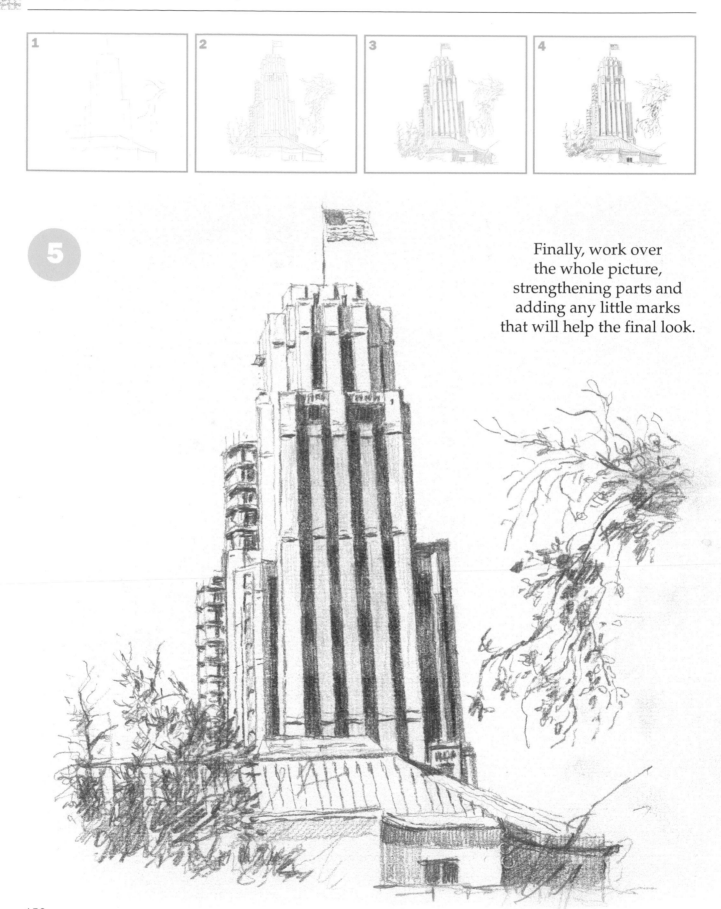

5

Finally, work over the whole picture, strengthening parts and adding any little marks that will help the final look.

 For your drawing from life, find a big building that you can easily
see in its entirety and remember that in the case of architecture,
most of the lines will be as straight as you can make them.

1

This building is the great medieval cathedral in Lincoln, England, which dominates the city. Lightly mark in the main shape and the houses around it.

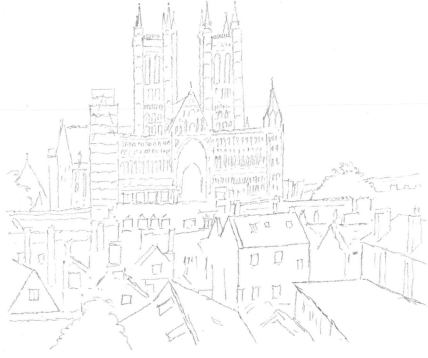

Next, draw in more precisely the detailed shapes of all the buildings that form the composition. The nearer buildings lead the eye to the cathedral in the background.

3

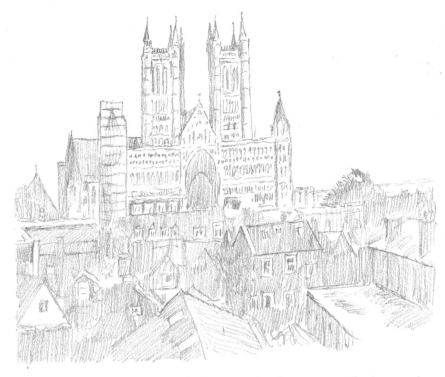

Now put in the lightest area of shade, which is quite tricky as the surface of the cathedral has many indentations and pieces of statuary projecting from it.

4

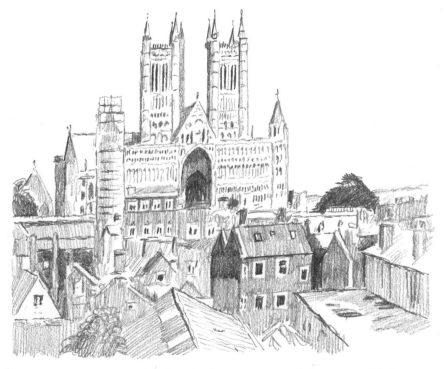

The next stage is to put in the darkest accents of tone, which are mainly in the deepest recessions in the cathedral front, the trees and the backs of some of the closer houses and their windows.

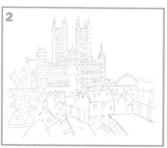
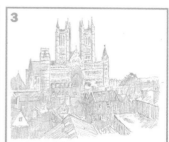
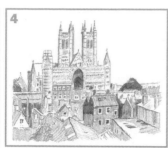

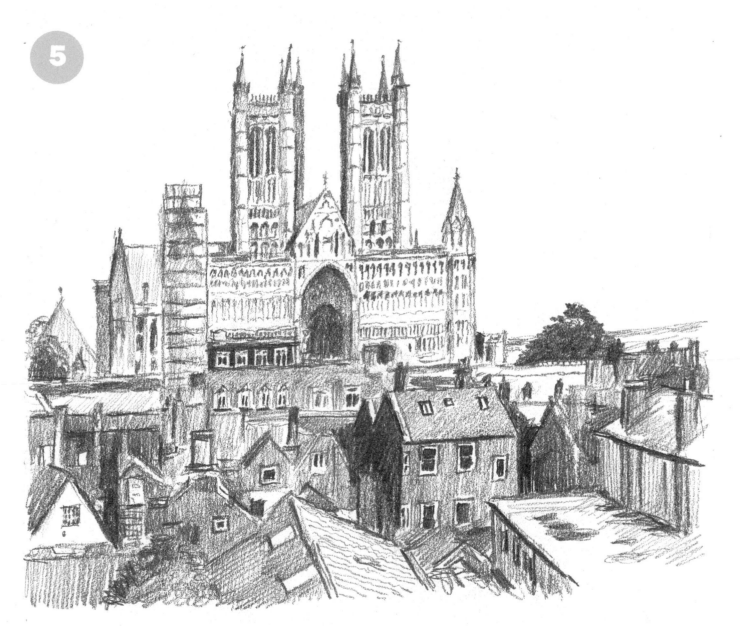

Finally, work over the whole picture, building up the variety of tones to bring a more three-dimensional appearance to the scene. This can take a bit of time with such an intricate subject as this.

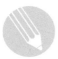 Once you feel you have done this successfully, tackle a large outside scene with an interesting landmark that gives some information about the location in which you live.

1

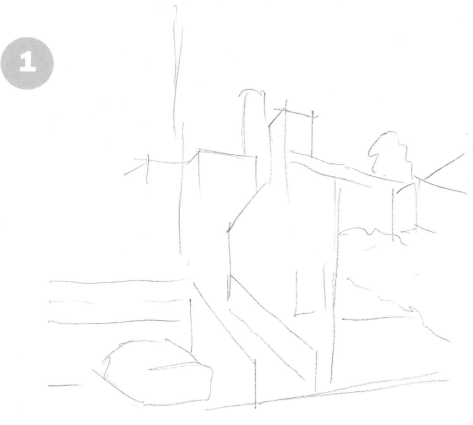

This project is about exploring your own locality and finding a way to make it into an interesting scene. Here I drew an attractive group of buildings in the suburbs. To follow my process, sketch in the outlines very simply to start with.

2

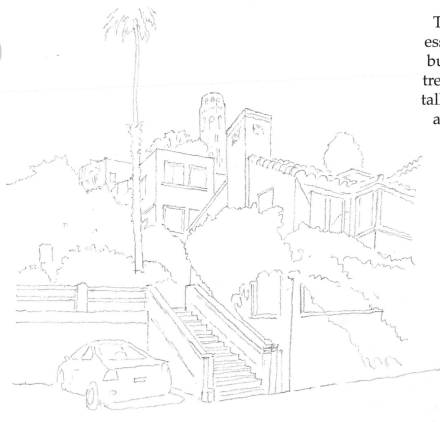

Then carefully draw the essential outlines of all the buildings and the massed trees, with one particularly tall palm tree near the front and the distant tower in the background.

3

The sun was shining strongly, so it is easy to see all the areas of shade here. For this stage, put them in using only the lightest tone.

4

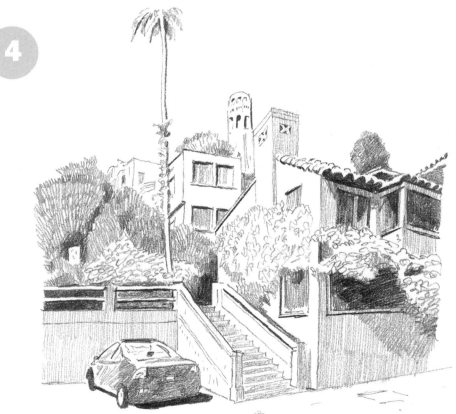

Next draw in all the darkest shadows where they define the shapes of the buildings and vegetation. The car in the foreground is an important device to give a sense of scale to the whole picture.

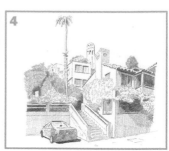

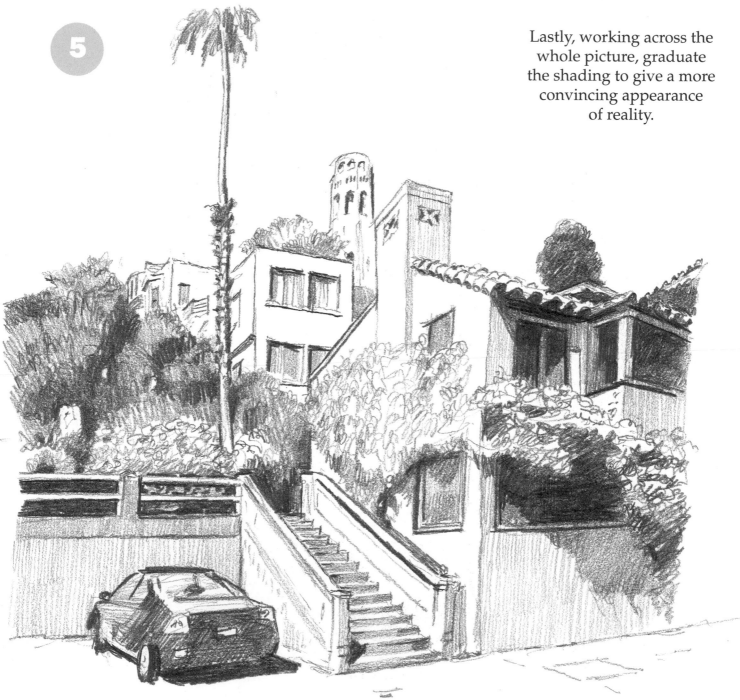

5

Lastly, working across the whole picture, graduate the shading to give a more convincing appearance of reality.

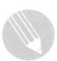 Now find your own local scene. Bear in mind that it is often better
to select a smaller area rather than a large one to get a
strong and interesting composition.

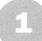

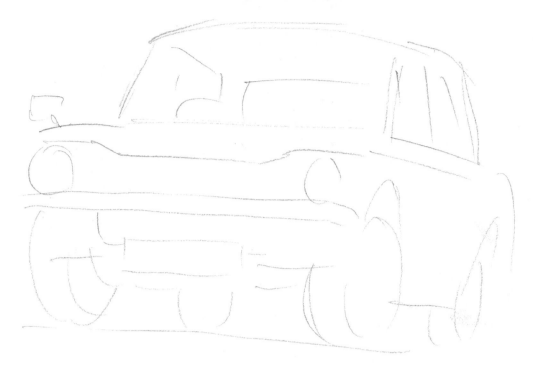

The intricate form of this classic Hillman Minx makes it a good
subject to draw. Sketch in the main shape of the vehicle very lightly,
as you might need to erase quite a bit of it later.

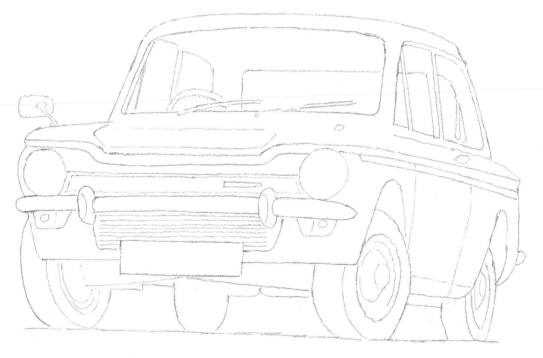

Now produce a more careful and accurate outline drawing that shows
all the main features of the car. Keep the lines lightly drawn at this stage.

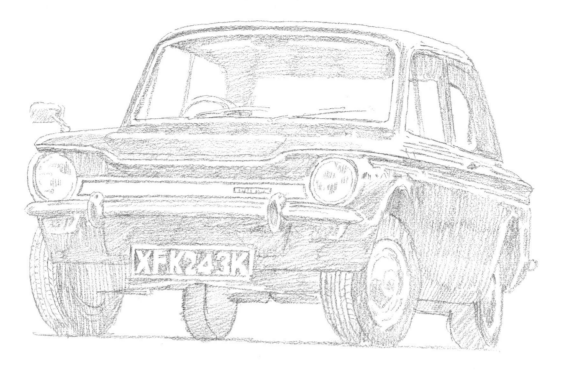

Put in an overall tone where the shadows appear on the car, keeping this uniformly light.

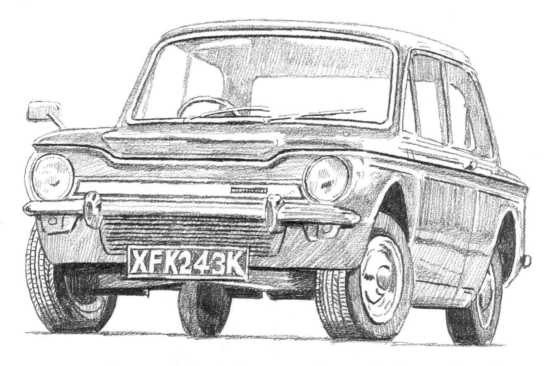

Now you need to put in the dark tones such as under the mudguards and around the wheels. Put these in very strongly, but don't blend them in at this stage.

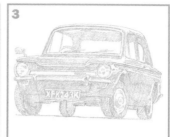
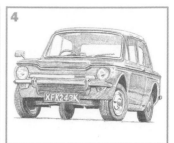

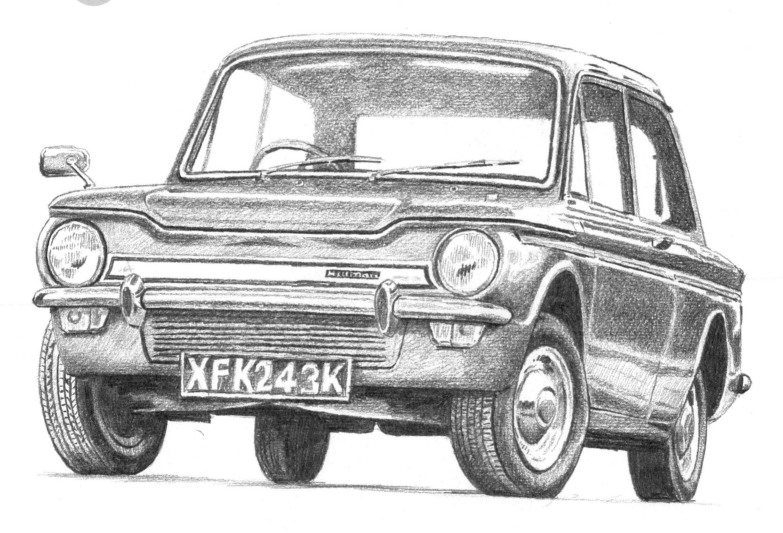

Now comes the blending process, where you add all the medium tones to help the vehicle look three-dimensional. Take your time on this in order to get the best result you can achieve.

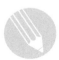 Now pick a classic car of your own choice to draw and see if you can produce a good effect with these methods. A car show is a good place to find one, or a car-owners' club event.

A VILLAGE SCENE

1

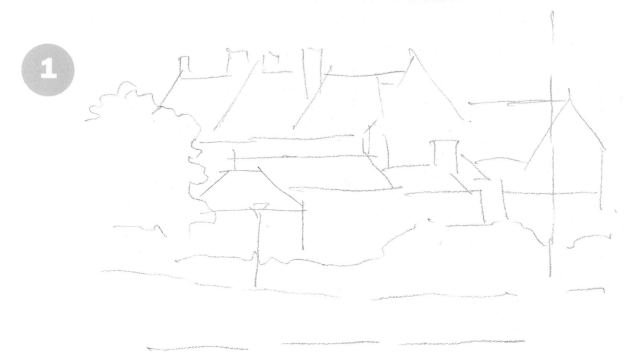

Here is a drawing of a village close to where I live, just showing a jumble of houses and their roofs. First of all, sketch in the main shapes to make sure that you get the size and proportions right.

2

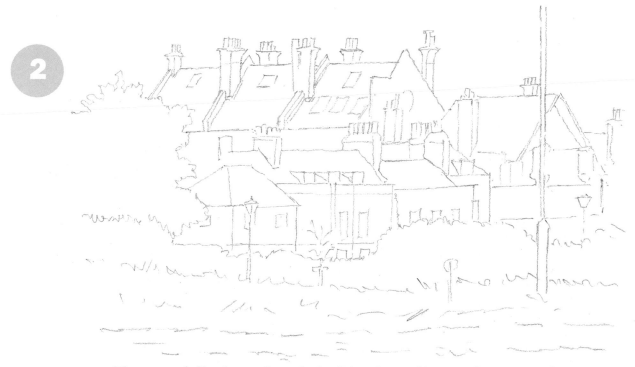

Then carefully draw the whole thing in outline, making sure that each shape fits in well with the rest of the composition. The hardest bit is getting the roof shapes correct in relation to each other.

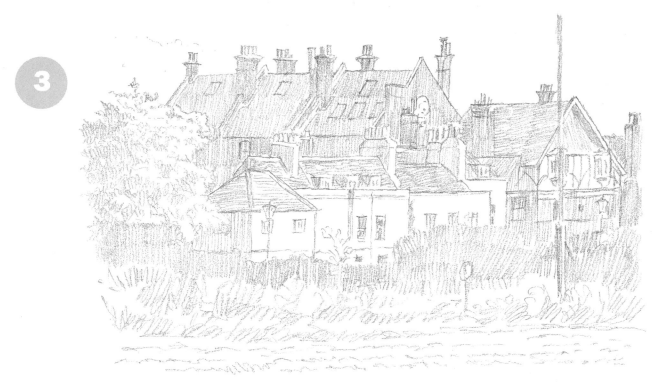

Put in the main areas of tone, which in this case are quite extensive.
Make the foreground vegetation more textural than tonal to keep the
contrast between the buildings and the plants.

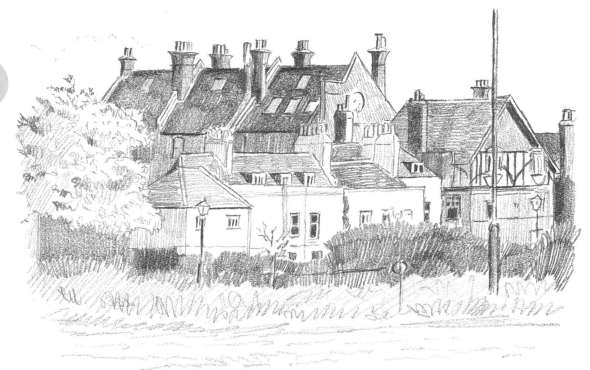

Now put in the very darkest tones, which are particularly obvious on
the roofs and in the windows.

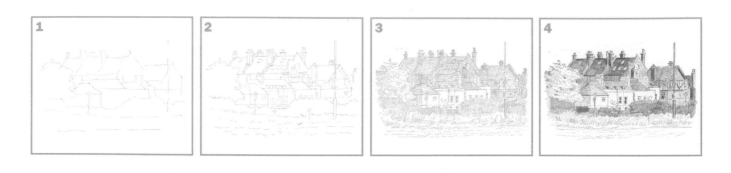

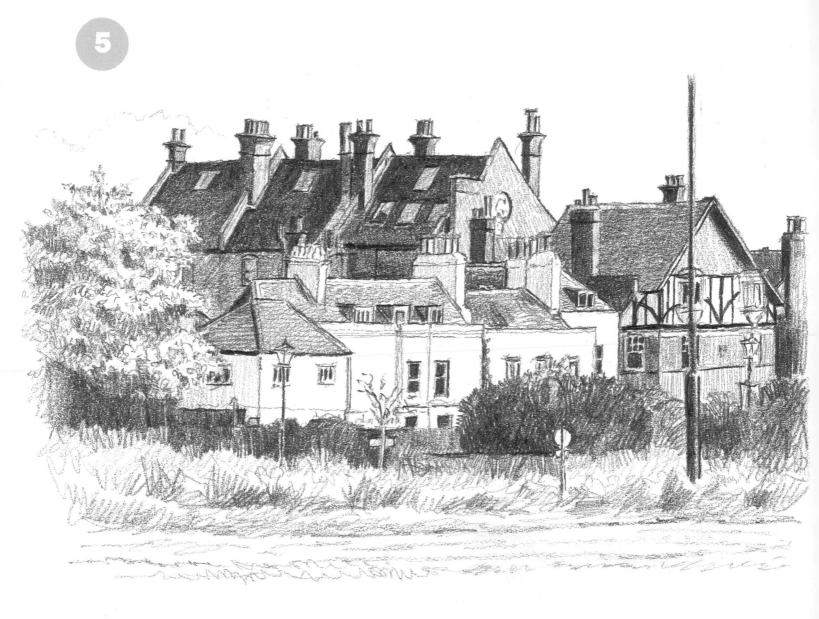

To finish, work over the whole scene, getting the strengths of tone as accurate as you can. This gives the final composition a more three-dimensional and realistic feel to it.

Next, have a go at a place near where you live that catches your interest. If you can see a good composition from your window you can even draw it in rainy weather, but note that the tonal contrasts will be lessened in dull light.

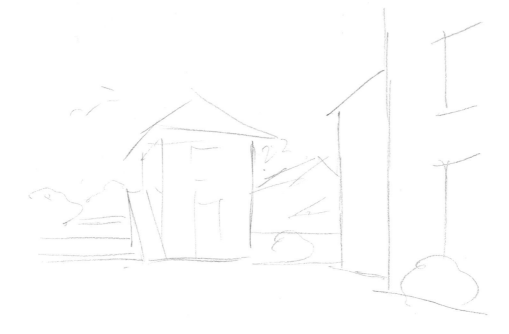

This group of 19th-century buildings near Sonoma, California, are the remains of the original establishments from the Californian Republic days. As usual first mark in the main shapes of your composition.

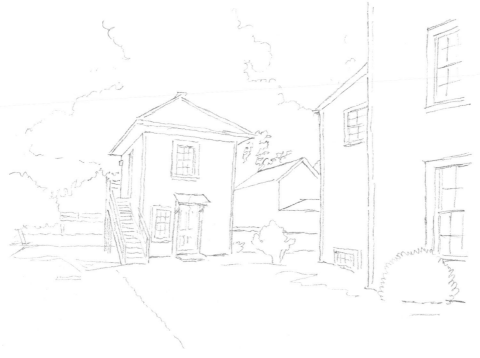

Next we put in all the shapes in a simple but accurate outline. This should be as accurate as can be made at the time, and careful alteration of the shapes at this stage is worth the trouble.

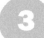

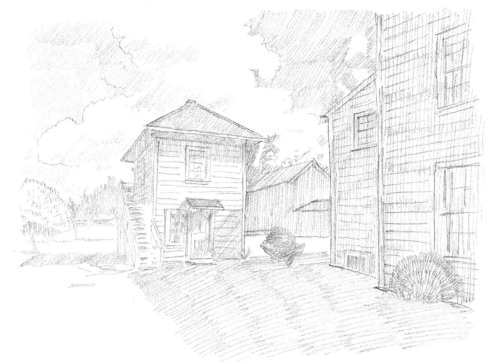

Next we can put in the areas that appear in the shade, all in a very light tone. Include the blue sky at this stage so that the clouds can be seen.

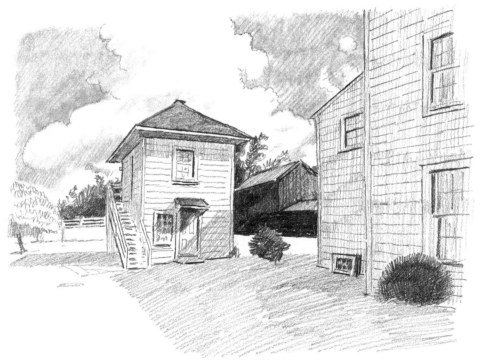

Now we mark in all the very darkest tones to begin to get some idea of depth. The dark sheds in the centre background help with this, because they make a break between the two main buildings. Use a paper stump to smudge the marks denoting the blue sky. This will make it look further away.

5

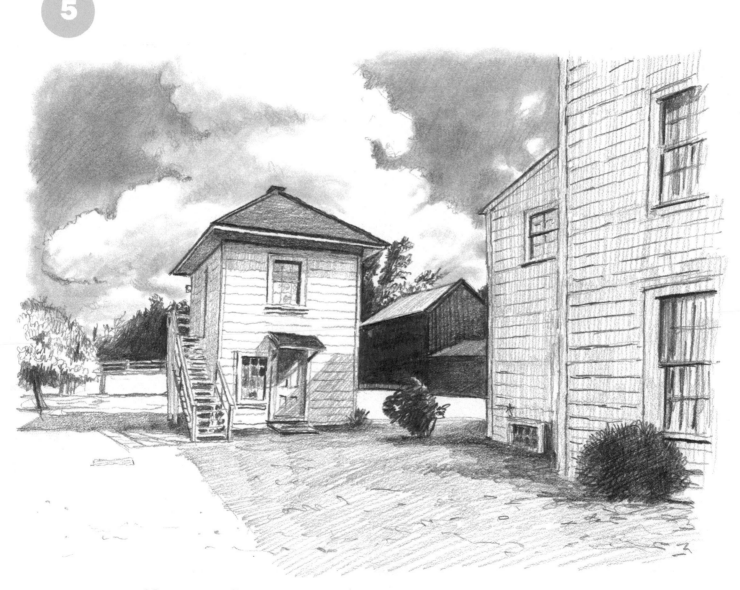

Now generally work over the whole picture until we can see it is beginning to look more like the actual scene. The more you can put into this the more convincing the final picture will be.

 Now comes your turn. Choose a limited area to work from as I have because then the handling can be more confident.

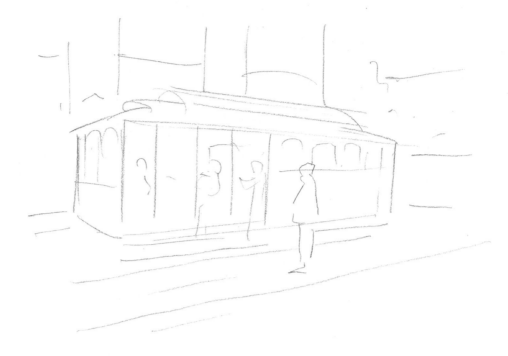

A cable car in San Francisco gave me an interesting setting and of course a number of people to draw. You can omit the people in your version if you prefer. Mark in the main shapes to start with.

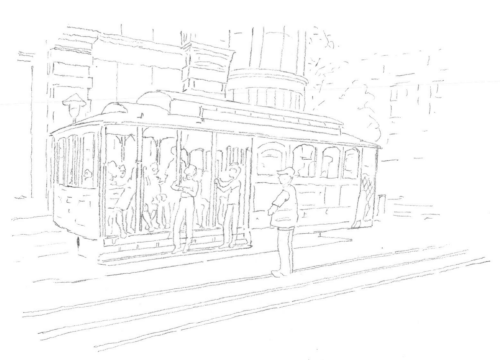

Then carefully draw in everything in a simple outline, trying to make all the shapes and their relationships as accurate as possible.

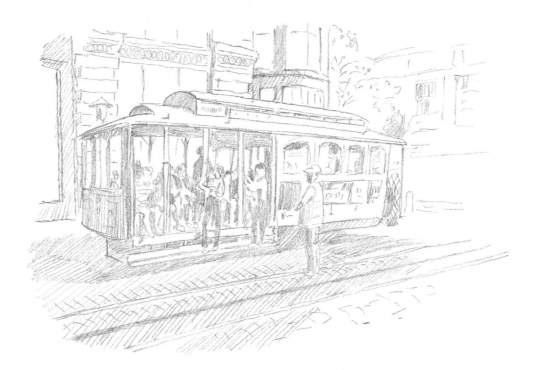

Put in the main areas of tone with light layers of shading, including the texture on the street surface.

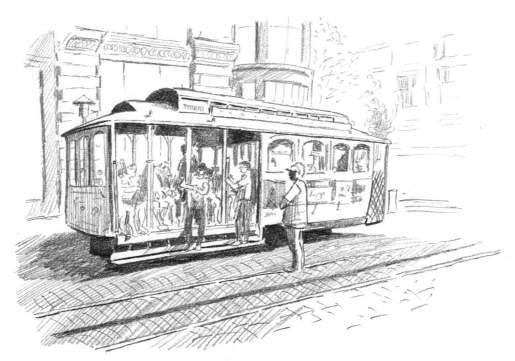

Next, mark in all the dark tones to begin to give the picture some depth. These are mainly the shadowed areas on the cable car.

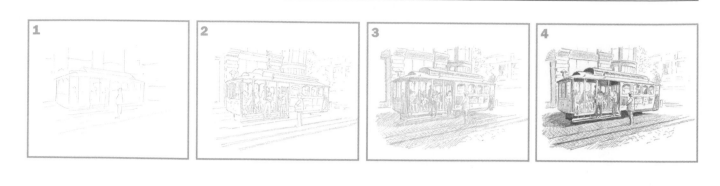

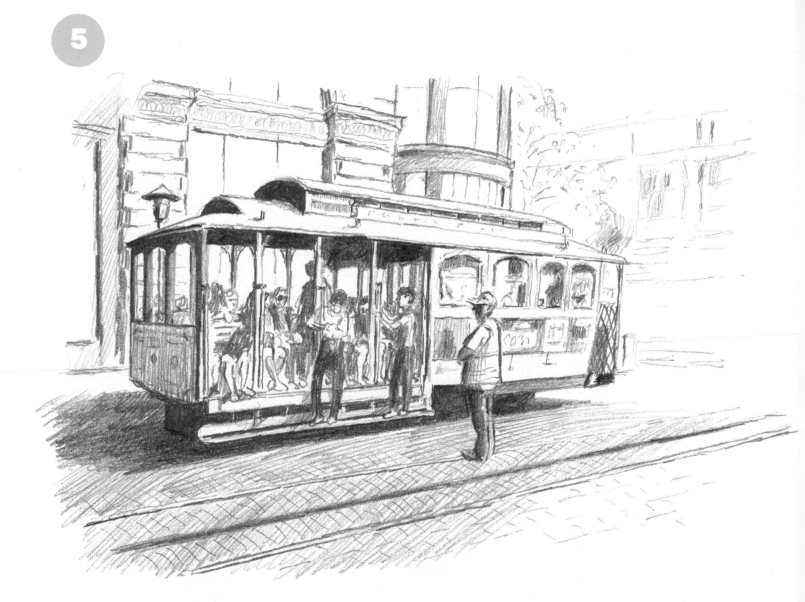

Finally, work over the whole scene, aiming for as much subtlety of shading and definition as possible.

 For drawing from life, public transport in your local area should offer you plenty of opportunities. A big advantage is that if the bus, cable car or train you are drawing departs, the next one will probably look exactly the same.

1

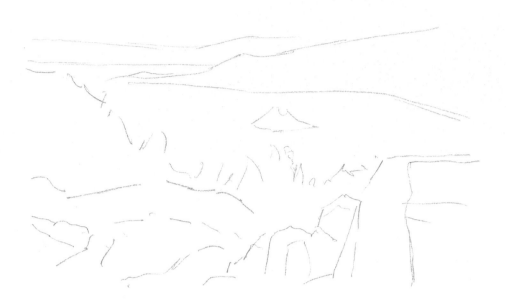

This rugged, wild landscape is seen from a hillside above a lake with a small island. Begin your drawing by putting in the main areas quite lightly so that the composition of the picture is established.

2

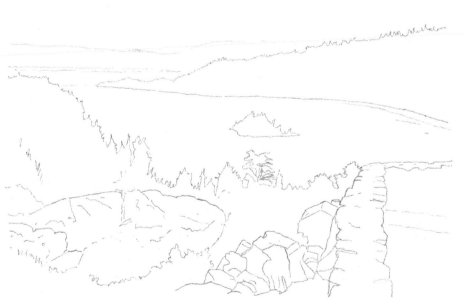

Now draw all the main parts of the scene in simple outline. Put in the background very lightly indeed, and the middleground and foreground with increasing emphasis.

3

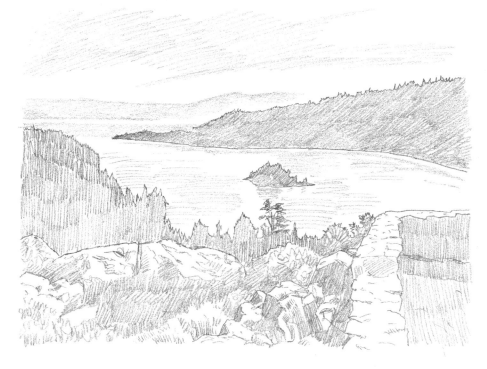

Now comes the tonal stage, where you can make the far landscape much fainter than the rest. In the foreground, most of the tones will be produced by texture rather than smooth shade.

4

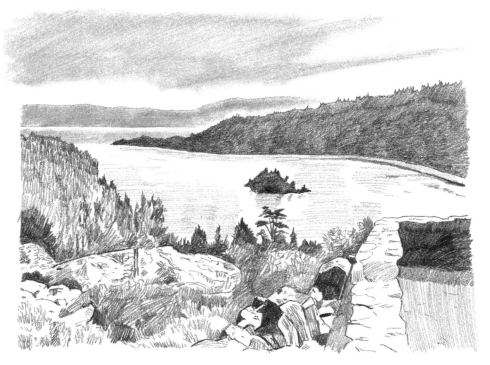

Rub the sky and far hills with a paper stump to soften the effect, then put in all the darkest tones and textures. Note how dark the island and foreground shadows look against the lake and highlighted rock.

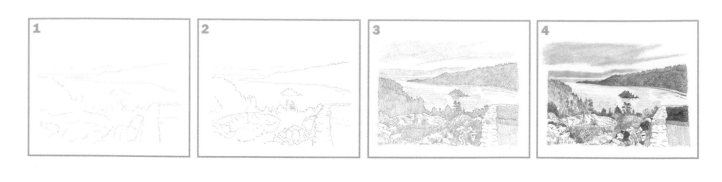

5

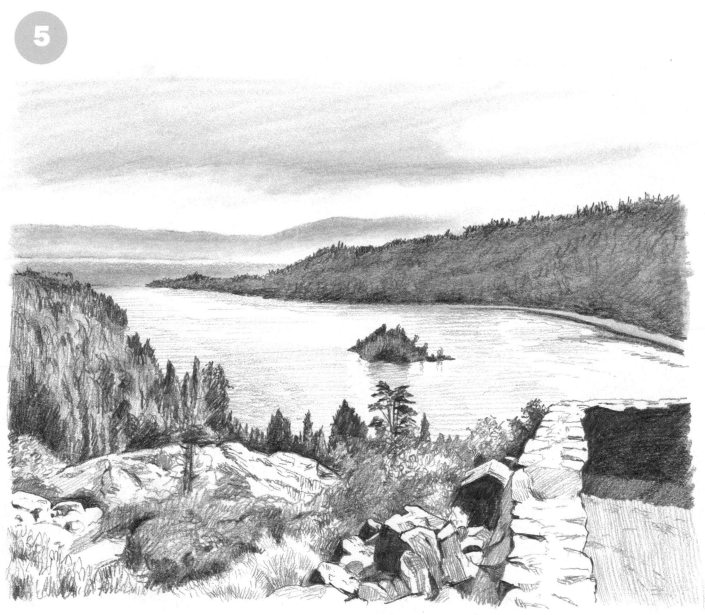

Now work on the mid-tones, some of which can be smudged with a paper stump to create more subtle effects. The nearest rock shadows are the very darkest tones, almost solid black.

 You may not have a local landscape as dramatic as this, but try
to imbue the scene you choose with as much drama as possible,
mainly by means of contrast of tone and shape.

PEOPLE ON THE BEACH

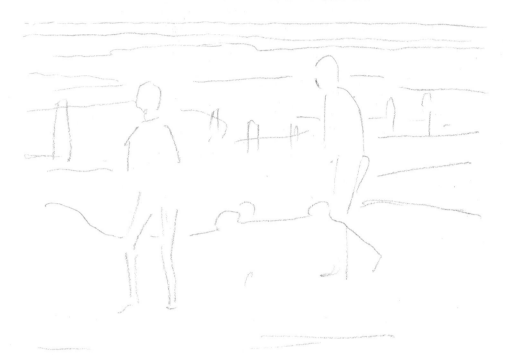

This picture of a mother and daughter throwing pebbles on the beach is drawn from photographs as they were in constant motion. Begin your drawing with a light sketch to establish the composition.

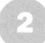

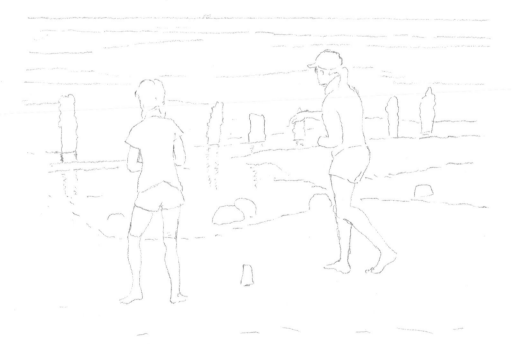

Now carefully draw everything, making sure that the shapes and proportions are as accurate as you can get them. Don't forget to put in the horizon line in the distance to give the feeling of space.

3

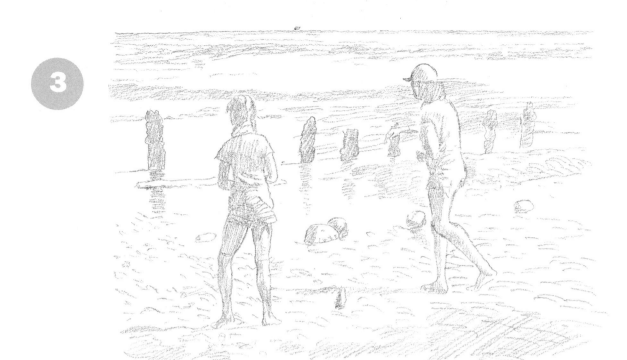

Put in the tonal areas in as light a tone as you can manage. Include
the distant sea and all the foreground sand and water.

4

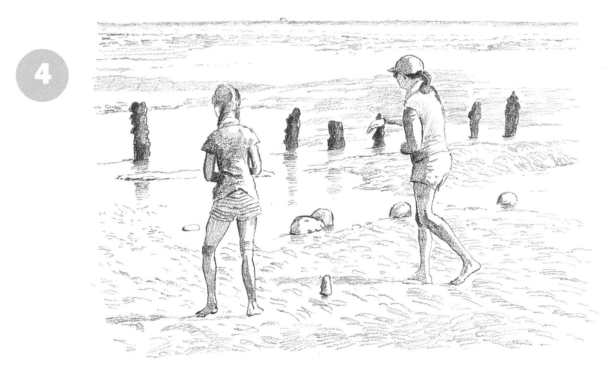

Now put in the strongest tones where they occur. They are mainly on
the figures and the old wooden posts.

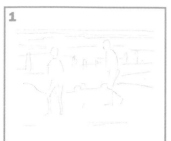 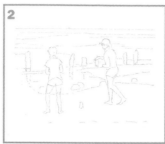 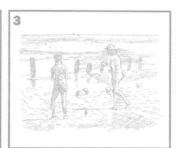 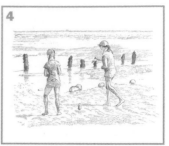

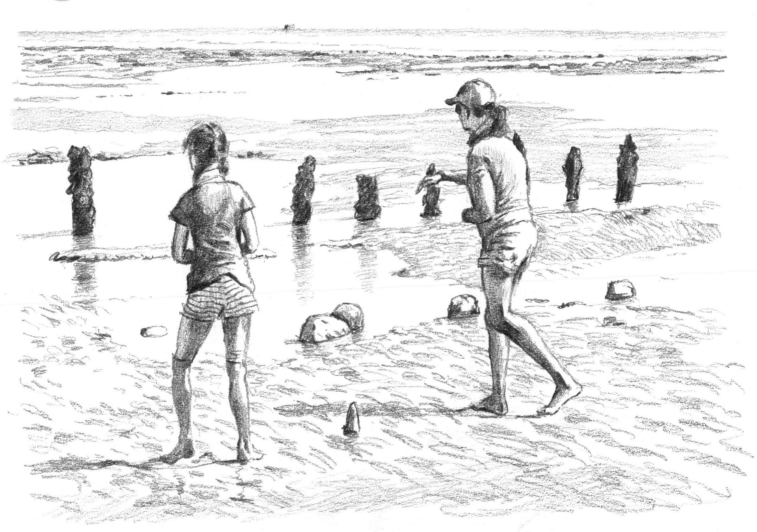

To complete the drawing, work over the whole picture with texture and tone to build the depth and feel of the scene. Take your time on this to make it as subtle as possible.

 Your own version of this kind of scene doesn't have to be set on a beach if you don't live near one – just find a couple of people playing around in the open.

A SEASCAPE

1

This project is a seascape showing an area that is fairly empty, with big waves crashing on the shore. Draw in the whole scene with very simple, sketchy lines.

2

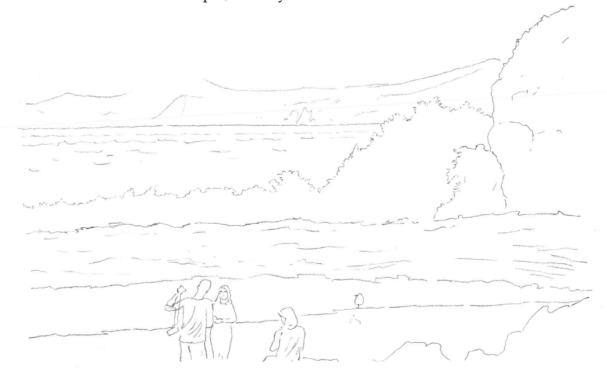

Now draw in everything that you can see with a light outline. The far hills are partly hidden by mist, so you can allow the line to disappear altogether here.

3

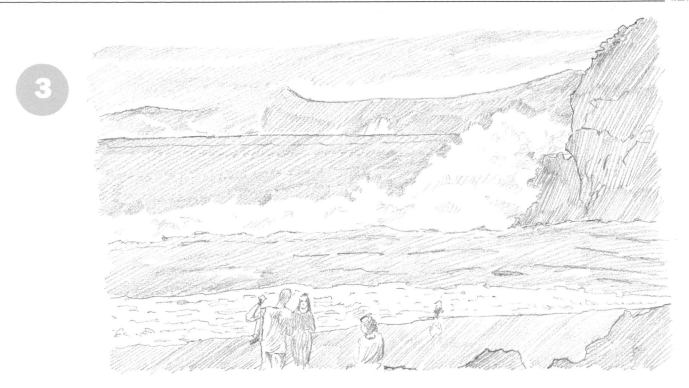

Next, put in all the shaded areas in one light tone, including some in the white foam. Add a little texture on the nearer shore and sea.

4

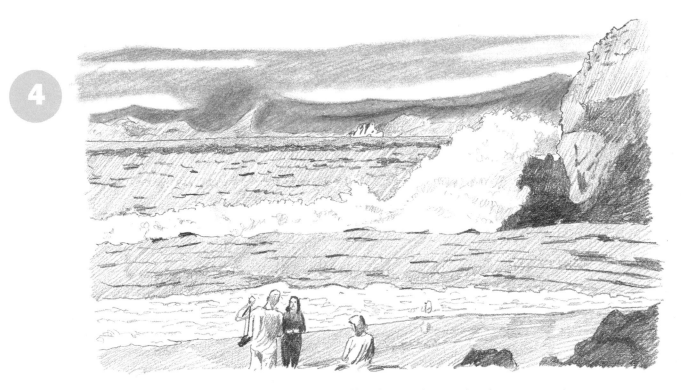

Now put in the darker tones, especially the rocks in the foreground. At this stage a bit of smudging with a paper stump on the sky and far hills will help to give more depth to the scene.

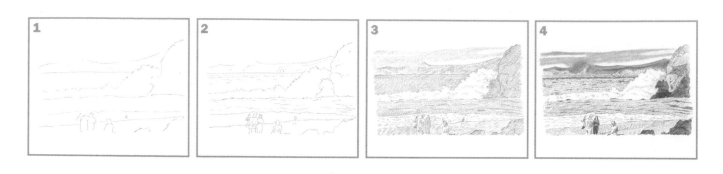

5

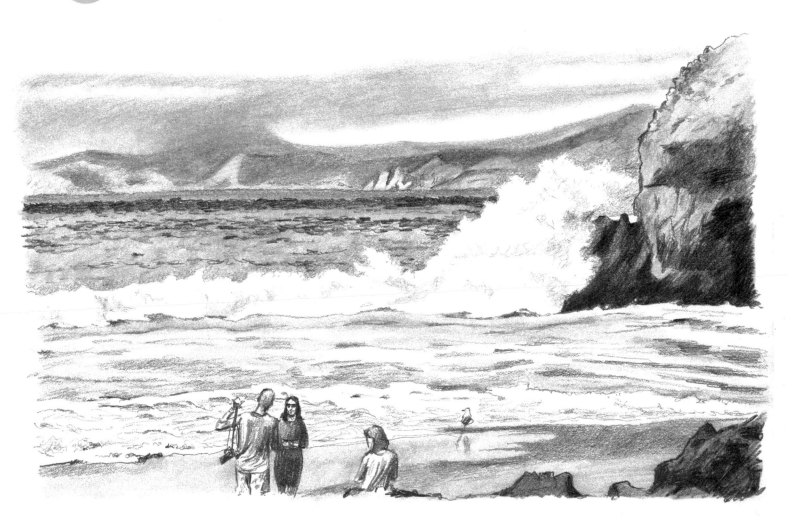

To finish, work over the whole scene with the paper stump to soften some of the tonal and textural effects. Keep the white foam as white as possible to create maximum contrast with the rest of the scene.

 Now it's your turn to try out a seascape of your own. Find one that gives you a nice feel of the sea and shore as contrasting elements. In this example the contrast is due to the large splash of foam against the rocky headland, with smaller waves across the main area of the bay.

1

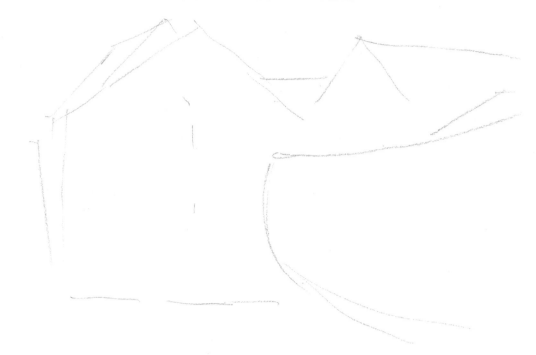

This scene of an old boat and sheds nearby is typical of many coastal areas. Start with a few lightly drawn lines that indicate the extent of your composition in terms of shape and proportion.

2

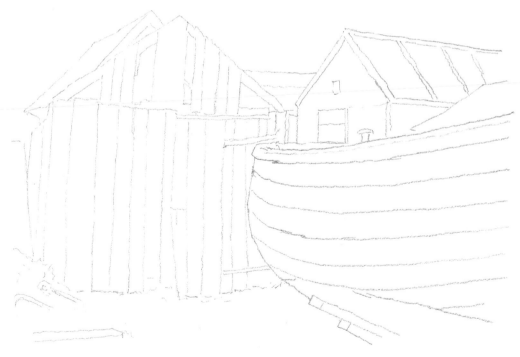

The next stage is to delineate the whole scene in a carefully drawn outline. Again keep the lines light because you may need to work over quite a lot of them later.

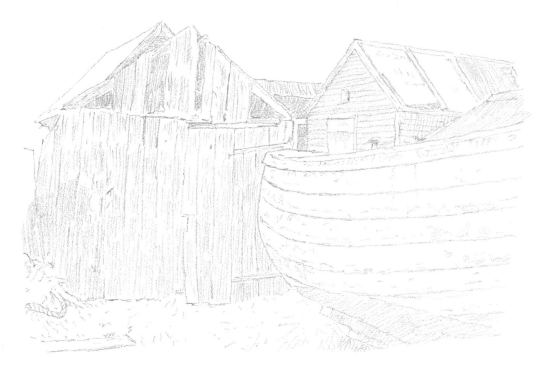

Put in the main areas of shade all in the same light tone, however strong some of them really are. Use tone to indicate the striated texture of the wooden planks of the sheds.

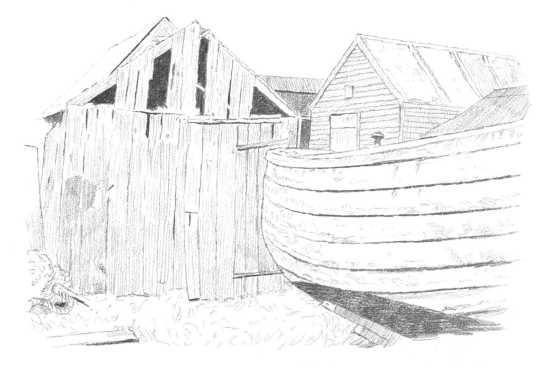

Now put in the very darkest tones, notably the spaces in the planks of the shed facing the viewer, where the dark interior is seen. The overlap of the planks that form the boat is another dark area.

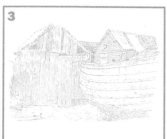
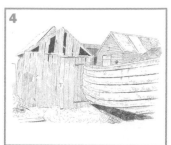

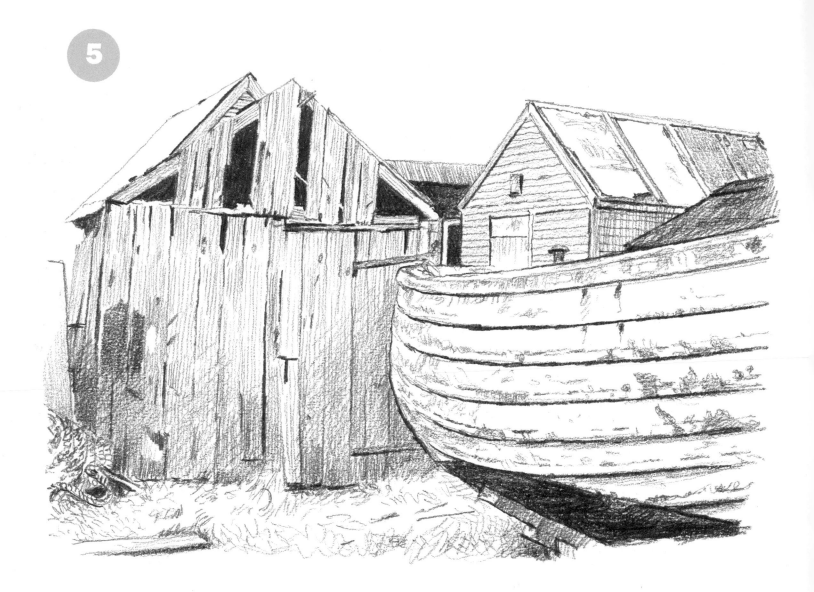

Finally, work over the whole picture, building up texture and tone.
Numerous small marks give a weatherbeaten feeling to the painted
boat and the old shacks.

 Boats and sheds are easy to find if you live near some expanses of water, but if not, just look for some old sheds that are fairly dilapidated. Allotments are often a good source.

1

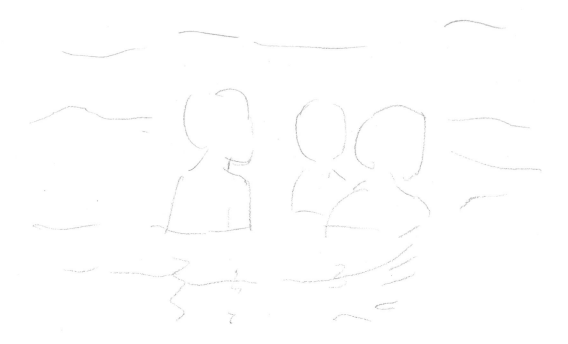

Here we have a group of family members bathing in the sea. The waves are strong, so they are facing towards them and floating up on their surge. First, sketch their heads and shoulders and try to get their proportions right in relation to each other.

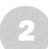

2

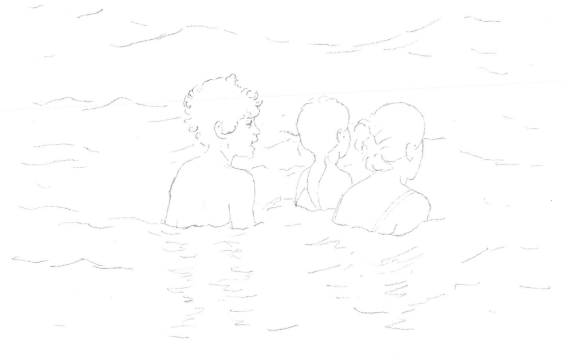

Next, carefully make an outline drawing, keeping it as simple as possible. Mark in the areas of the waves as well to give some background effect.

3

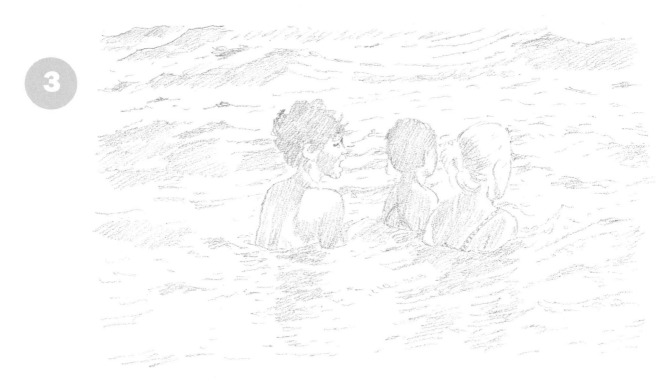

Now block in the main areas of tone, not forgetting the wave areas around the figures. Keep it all very light at this stage so that you can put in the darker tones effectively at the next stage.

4

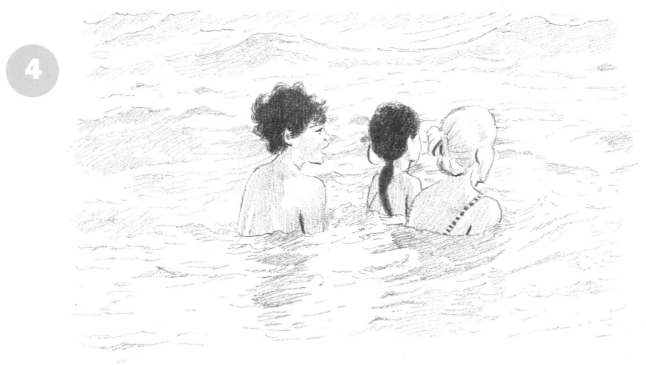

At this stage put in the very darkest tones, of which there are not many. They are mainly the dark hair of the two children, the edges of the arms and the shoulder strap of the adult.

5

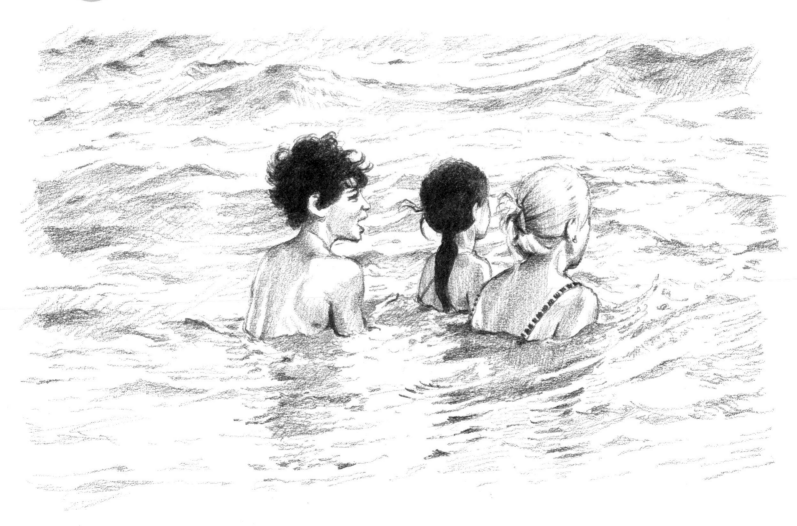

Now work over the whole picture, adjusting the marks of tone and texture until the drawing looks convincingly three-dimensional. Go carefully here and don't overdo the dark areas too much.

 For your own drawing you can take photographs of a similar scene to work from or draw directly from life, if your subjects will keep still for long enough. One way to tackle that is to draw each person separately and then group them together in your final drawing.

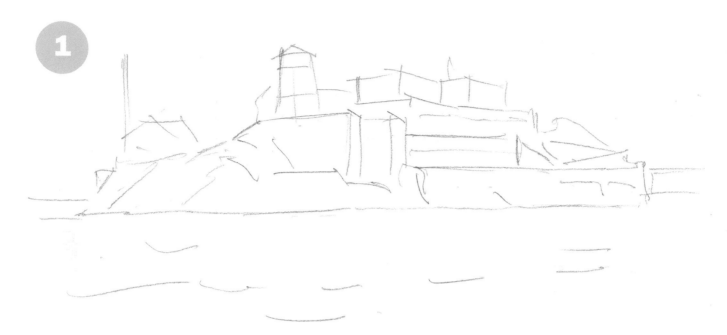

This example is of an island, but instead of an idyllic palm-fronded location I have chosen the old prison island of Alcatraz. Draw in the main bulk of the rocks and buildings and indicate the sea.

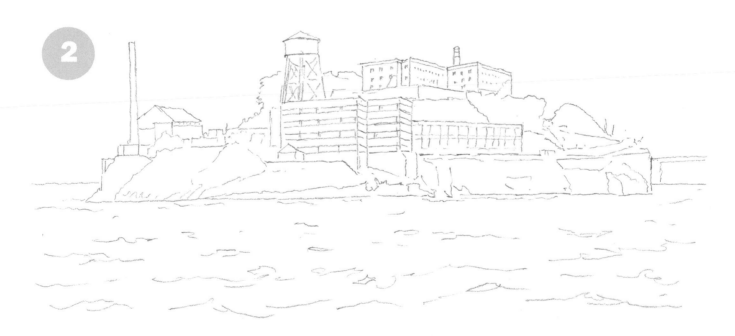

Next, carefully draw in all the shapes of buildings, rocks and vegetation and describe some of the nearer waves.

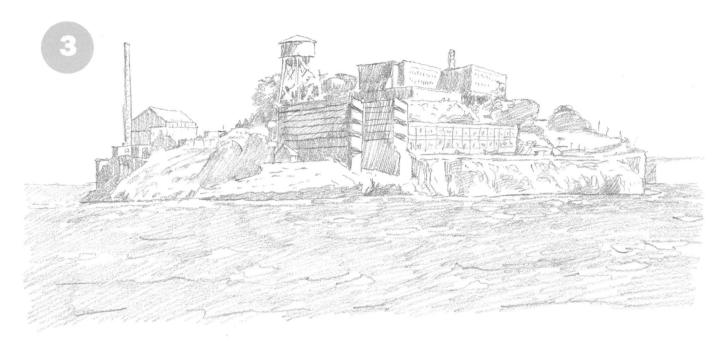

Put a light tonal layer over all the shaded areas. Include the main colour of the sea here, just leaving white slivers for the wave tops.

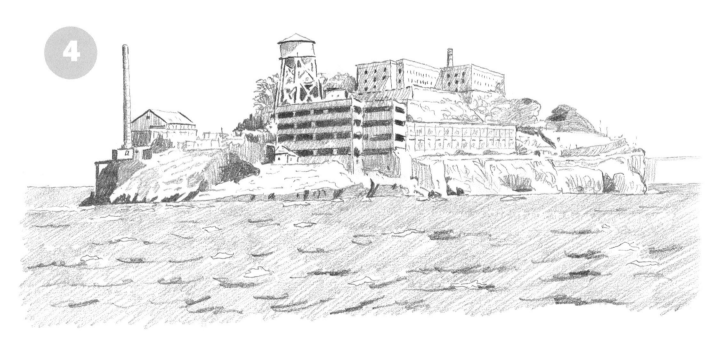

Now put in the darkest areas of tone, which are mainly the dark shapes of the windows in the buildings and the shadows on the edges of the rocks.

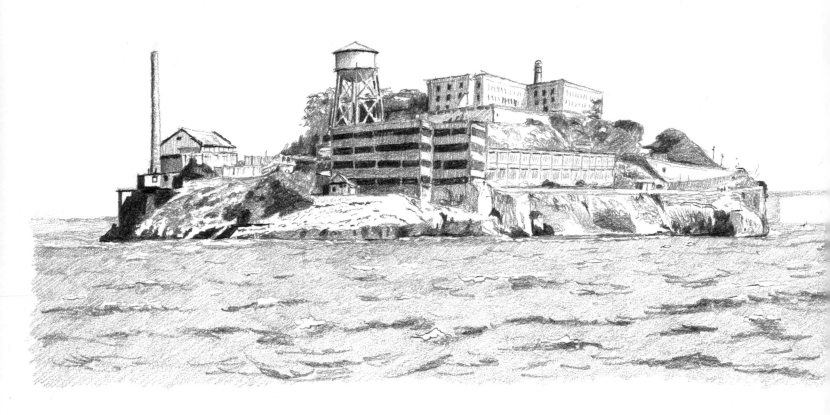

Finally, work over the whole composition, grading and texturing various parts of the picture until you are satisfied with the result.

 If you don't live near an island that you can draw from life you will be able to find plenty of photographs of islands, ranging from windswept locations in northern seas to hot tropical islands with sandy beaches and palm trees. Try drawing a variety of them, seeing how well you can describe the different types of waves and shores.